BRITAIN IN OLD PHOTOGRAPHS

DUMFRIES

DAVID CARROLL

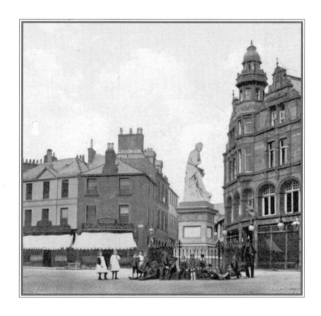

ALAN SUTTON PUBLISHING LIMITED

Alan Sutton Publishing Limited
Phoenix Mill · Far Thrupp · Stroud
Gloucestershire · GL5 2BU

First published 1996

Cover photographs: *front: High Street
and Midsteeple, 1960s; back: Liptons in
Queensberry Square, 1940s.*

British Library Cataloguing in Publication Data
A catalogue record for this book is available from the
British Library.

ISBN 0-7509-0985-4

Typeset in 10/12 Perpetua.
Typesetting and origination by
Alan Sutton Publishing Limited.
Printed in Great Britain by
Ebenezer Baylis, Worcester.

CONTENTS

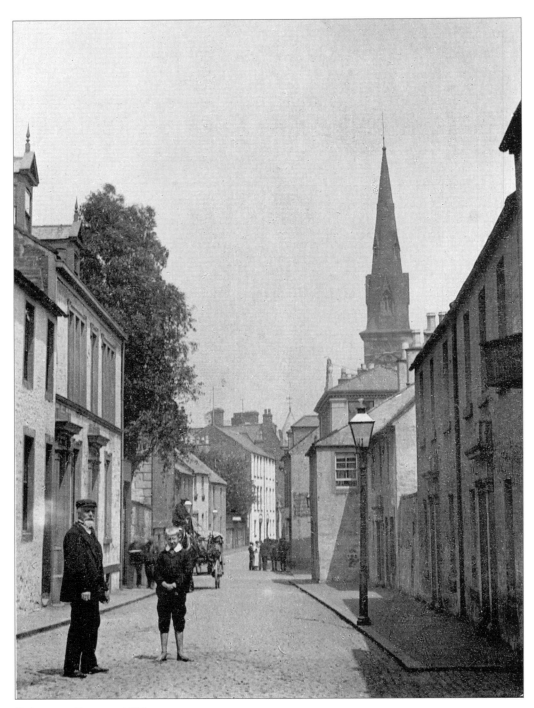

Shakespeare Street, *c*. 1900.

INTRODUCTION

Admirers of Tobias Smollett's last novel, *The Expedition of Humphry Clinker* (1771), will recall that the irascible Squire Bramble waxed lyrical about Dumfries in no uncertain terms. 'A very elegant trading town near the borders of England,' was how he described it, 'where we found plenty of good provision and excellent wine, at very reasonable prices, and the accommodation as good in all respects as in any part of South Britain. If I was confined to Scotland for life,' he added, 'I would chuse [*sic*] Dumfries as the place of my residence.' Bearing in mind that, in a national survey conducted only a few years ago, Dumfries was judged to be the second most desirable place to live in Britain (although the criteria which prompted this accolade escape me now), then Squire Bramble's sentiment was an admirable one indeed.

A Royal Burgh since 1186, and set on the banks of the River Nith, Dumfries has carved out its own special place on the world's stage, not least because Scotland's national bard Robert Burns lived, wrote and – on 21 July 1796 – died at his home in what is now called Burns Street. It is impossible to stray far in the town without being reminded of the fact that he is intricately woven into the fabric of the place. Burns House, the Globe Inn, the Mausoleum in St Michael's churchyard and the marble statue designed by Amelia Hill, which occupies a commanding position at the junction of High Street, Buccleuch Street and Church Crescent, are just a few of the ports-of-call along the town's 'Burns Trail' which testify to his presence.

Over the centuries, Dumfries has been touched by some of the most significant events in Scotland's colourful history, and a full account of these together with much else besides, can be found in William McDowall's definitive *History of Dumfries*, which was first published in 1867 and updated a decade ago with a supplementary chapter added by Alfred Truckell, the highly respected local historian and former Curator of Dumfries Museum. It is the essential tool for anyone – scholar and layman alike – with an interest in the town.

The aim of this present book, however, is to provide a glimpse of everyday life in Dumfries (with some special occasions thrown in for good measure) through the use of old photographs – always that most potent of weapons for evoking the past. Although a small proportion of these have been drawn from local archive sources, by far the

majority have come from the private collections of individuals, local firms and organizations.

It is probably as true of Dumfries as it is of almost every town in the land, that the past century has visited the greatest transition of all on the place. (No doubt many townsfolk would aver that the most significant event during that period was the incorporation – in 1929 – of the two burghs, Dumfries and Maxwelltown.) Succeeding layers of change have come thick and fast, with the net result that many of those elements which contributed to the singularity of the town have been watered down or even dissolved away altogether. On the debit side, for example, Dumfries is no longer a thriving port, the textile mills have closed and the clog makers have faded out of existence. Pedestrianization has crept up over the past few years and the High Street, with its fair share of the uniform façades of national retailers, has lost some of its old character. On the other hand, substantial firms such as Nestlé, Gates Rubber Company and ICI have moved in to provide welcome employment. Meanwhile, the Midsteeple still presides over the High Street; Scotland's oldest working theatre, now home to the Guild of Players, can still be found (newly refurbished) in Shakespeare Street, and the Museum's Camera Obscura is the oldest astronomical obscura of its type still in use in the world. And that is only a part of the story. Some of the remainder may be glimpsed through the assortment of photographs which comprise this book.

Of course, every effort has been made to establish the accuracy of all dates and information given in the text. Where documentary evidence has been available I have drawn from it. Otherwise, I have relied upon the collective memory of those many people (listed on page 126) who were kind enough to provide me with photographs and to share their reminiscences. Similarly, every attempt has been made – where appropriate – to trace the copyright holders of photographs. It has proved to be a labyrinthine task, and I can only apologize for any unintentional omissions.

I hope that I shall offend nobody who has provided me with photographs if I mention two people who have been of particular help to me during the preparation of this book. Firstly, Ian Ball, who kindly allowed me unrestricted access to his extensive postcard collection; and secondly, Ernie Smith, a keen local historian, who has given so generously not only of the photographs in his possession, but of his time and knowledge as well, throughout the whole of this project. (This book might have been much thinner without his contribution!)

Lastly, I am grateful – as always – to Bernadette Walsh, who helped me to make the final selection.

David Carroll, 1996

ON THE WATERFRONT

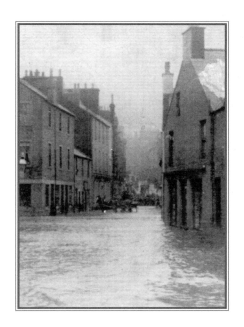

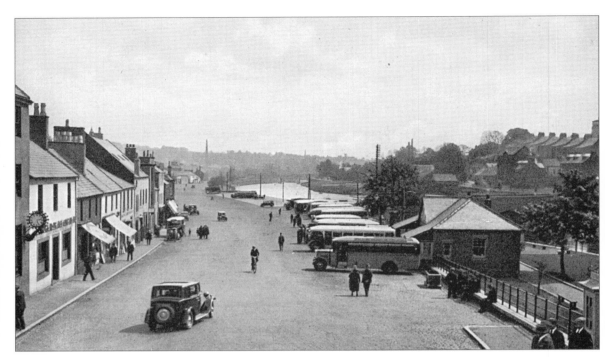

Whitesands has always been the main departure point for the country 'bus services as, in fact, it remains to this day. This 1930s photograph shows the vehicles reversed against the pavement, a practice only recently stopped with the construction of 'bus stances (nearly fifty years after the idea had first been suggested). The 'bus nearest to the camera belongs to Carruthers of New Abbey, who operated the service from Dumfries to Southerness for many years.

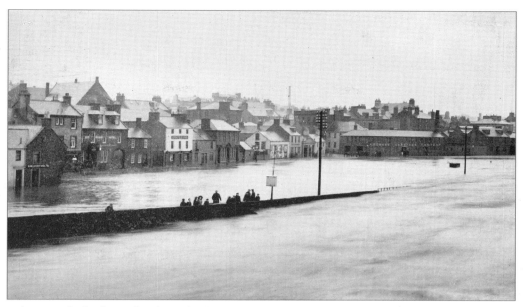

A depressingly familiar sight: the Nith, that 'most fickle of rivers', as it has been called, in flood along Whitesands on 10 December 1909. It has been ever thus, and hardly a year goes by without similar scenes occurring, although not usually on so grand a scale as this.

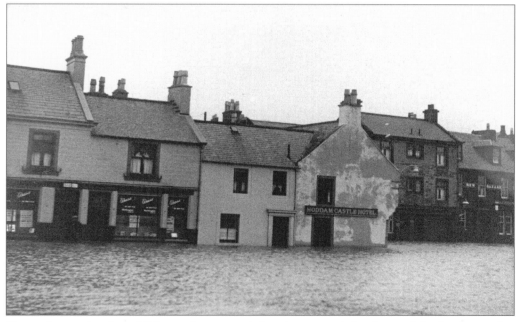

The residents and traders of Whitesands must surely have been overwhelmed not only by flood water, but by a feeling of *déjà vu*, as the Nith overflowed again four months later.

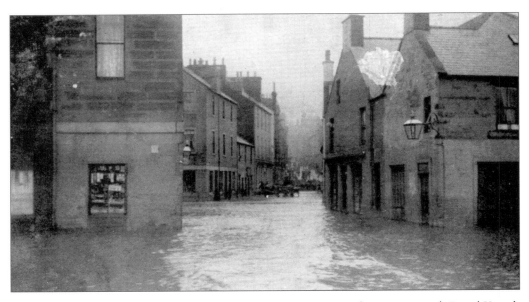

At a swift glance this could almost be Venice, but the architecture gives the game away. It's Friars' Vennel, on 2 March 1910, with the overflowing Nith making a valiant attempt to reach the High Street!

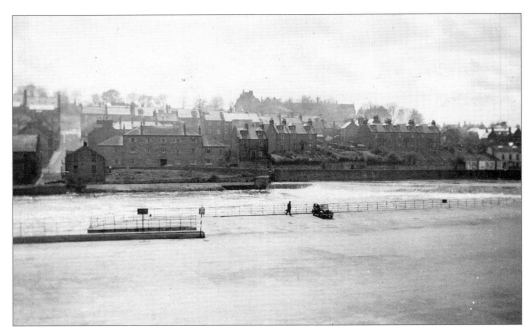

A panoramic view of Whitesands and the Nith, before blocks of flats were built on the Maxwelltown side. There are plans afoot for the radical redevelopment of Whitesands, to include redesigning the riverside area with seating, trees and screening to minimize the present effects of car-parking.

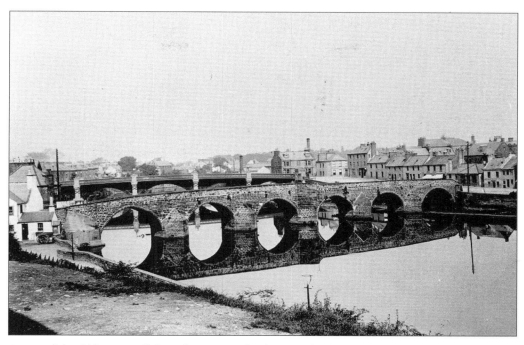

A view of the Old (Devorgilla's) and New (Buccleuch Street) bridges spanning the Nith, taken from the Maxwelltown side by John Rutherford in 1893.

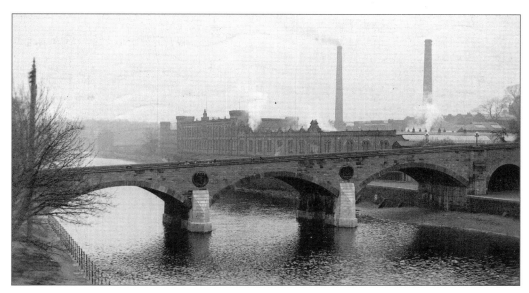

Looking across St Michael's Bridge (only a year old when this photograph was taken in 1928) and the Nith, to the Troqueer and Rosefield textile mills, which were once such an important source of employment in the town.

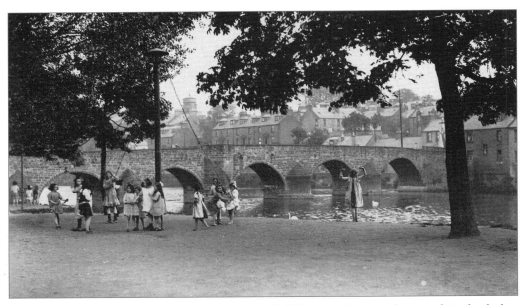

There is almost a pre-Raphaelite quality to this group of children, playing around a maypole in the shadow of the Old Bridge, *c.* 1913. Note the free spirit who has struck out on her own to dance at the edge of the Nith.

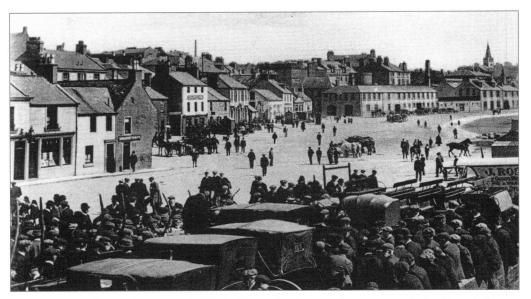

An auction on Whitesands in the early 1900s. Livestock sales were held here regularly, although there is scant evidence of any animals present on this occasion. However, there is one certainty: the many pubs strung out along Whitesands would have enjoyed a brisk day's trading.

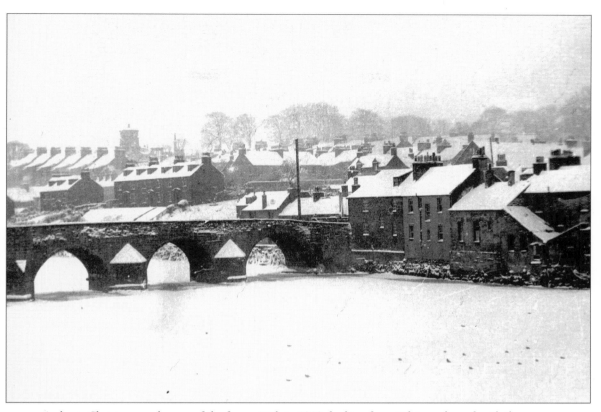

A classic Christmas card scene of the frozen Nith in 1940, looking from Whitesands, and with the snow-clad roofs of the town rising in tiers beyond. Although it was hitherto not such an unusual occurrence in winter, the Nith – perhaps owing to subtle climatic changes – has not frozen over, to the extent that its surface could be safely walked upon, for at least the past twenty-five years.

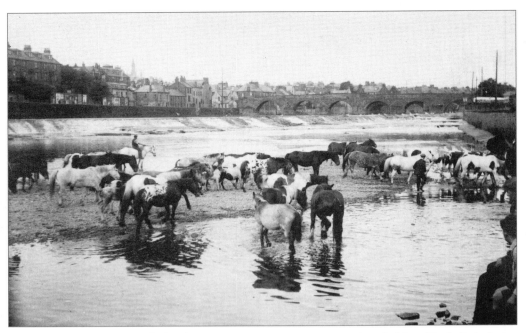

There was a time when Pinder's Circus came to town every year, and settled into Dock Park during September's Rood Fair. Seen here in about 1918, circus ponies being watered in the Nith became a familiar sight.

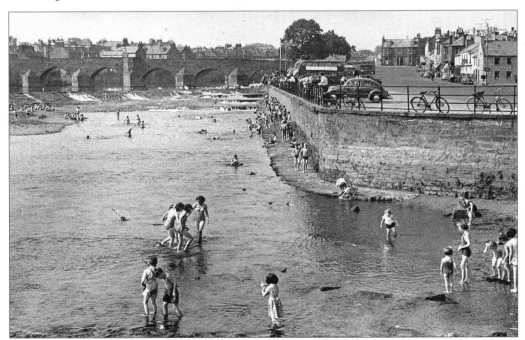

Children, too, enjoyed splashing about in the Nith, as this 1950s photograph shows. Youngsters often bathed in the river during the long, hot summer days when the water-level was low, and before the town's excellent riverside swimming-pool was opened.

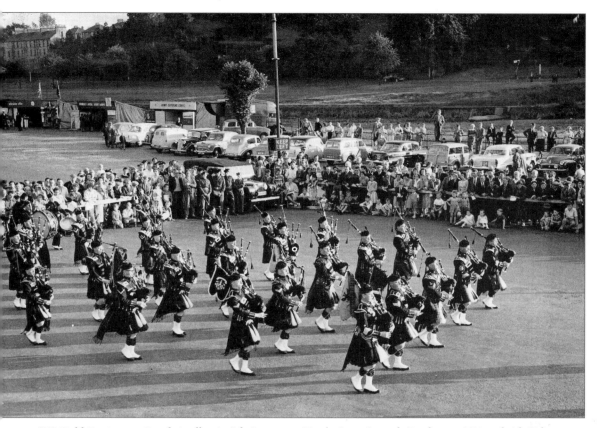

279 Field Regiment (Royal Artillery), 5th Regiment King's Own Scottish Borderers (TA) and 6th/7th Regiment Cameronians (TA), cast impressively long shadows in the sunlight of a late summer's day by the Nith, as they beat a Combined Retreat on Whitesands in September 1959, for the entertainment of assembled tourists and townspeople alike.

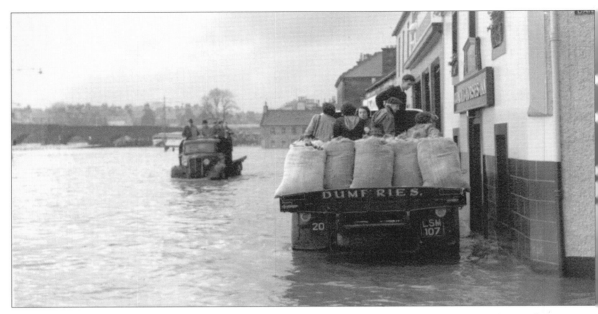

Here we go again – but the lorry delivering sandbags to the beleaguered properties along Whitesands on this occasion, during the 1950s, has arrived too late to prevent the cellar of the Coach and Horses from being engulfed by flood water.

AROUND THE TOWN

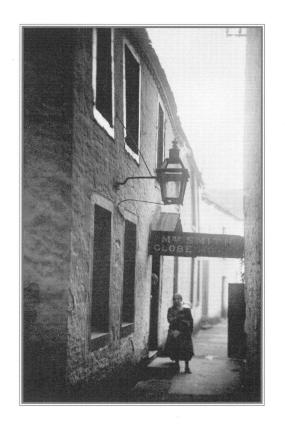

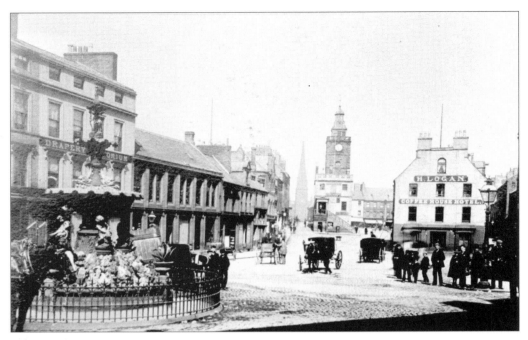

A view of the High Street and Midsteeple, captured by John Rutherford in 1893. Note the group of people on the right, who seem to have been drawn by the unusual spectacle of a photographer at work; rather as today, perhaps, we might be similarly intrigued by a television film crew in action around the town.

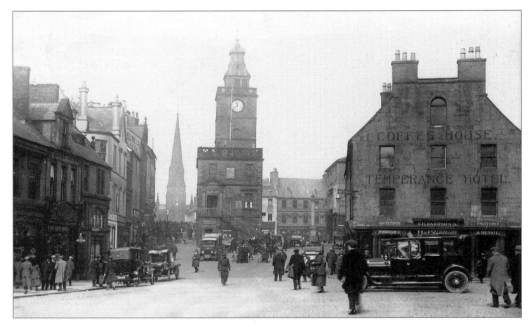

Thirty years later, in the early 1920s, the High Street itself appears outwardly unchanged; the major difference being that here, as everywhere else, the horse had been firmly ousted by the combustion engine. Pearson's Wolseley taxi can be seen parked on the right.

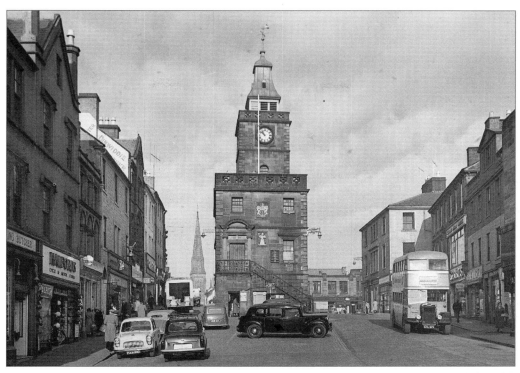

The High Street and Midsteeple in the 1960s. Times they were a-changing with the advent of the High Street multiples, and Dumfries began to lose many of the local shops and businesses that gave the town centre its unique character. This area has now been pedestrianized.

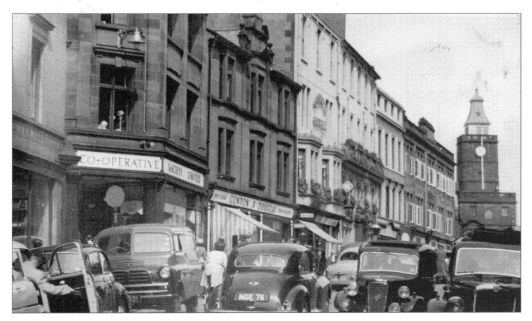

Mid-1960s traffic chaos near the junction of High Street and Assembly Street where today, in this pedestrianized quarter of the town, there is barely a car to be seen.

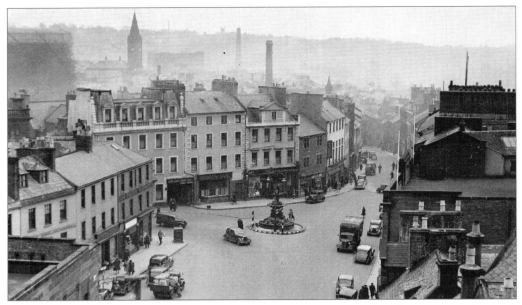

A bird's-eye view of the High Street and of the ornate fountain which stands at the junction with English Street, taken from the top of the Midsteeple during the 1930s. The fountain (which dates from 1882, replacing an earlier fountain on the site) was erected to commemorate the introduction of water to Dumfries in 1851, piped from Lochrutton Loch 4 miles west of the town.

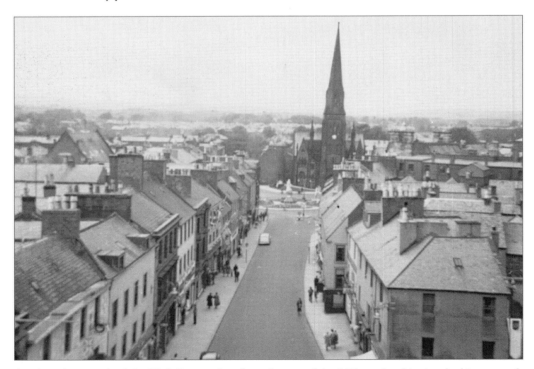

Another photograph of the High Street taken from the top of the Midsteeple; this time looking towards the Burns Statue and Greyfriars during the early 1950s.

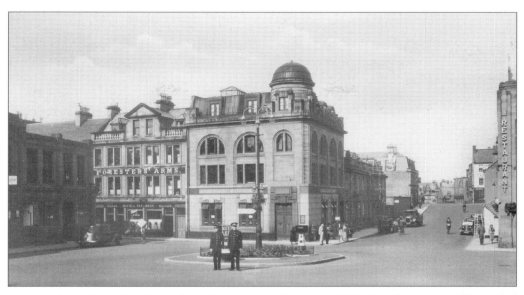

Looking along Great King Street from Queensberry Square, *c.* 1930. The Queensberry Monument (centre), designed by Robert Adam, was moved in 1935 during alterations to the road, and placed outside the County Buildings in English Street.

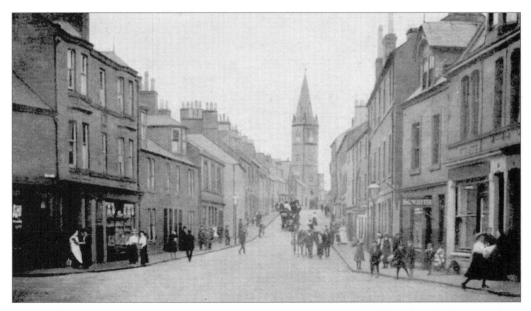

St Michael Street at the turn of the century, framing the tower and spire of St Michael's Church, where Burns worshipped when he lived in the town. The spire has been absent of late. It was found to be unsafe and removed in November 1994, sparking off strenuous fundraising efforts to pay for the necessary repairs.

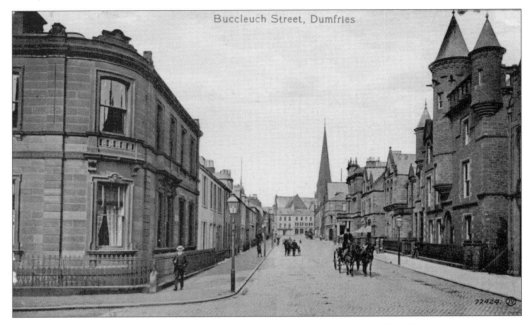

Buccleuch Street, looking towards Greyfriars, *c.* 1916. The road was originally laid out in the 1790s, and is still dominated by the distinctive turrets of the Sheriff Court House, which was completed and opened in 1886. Scotland's last public execution was carried out at the old prison (on the present site of the Clydesdale Bank) in Buccleuch Street in 1868.

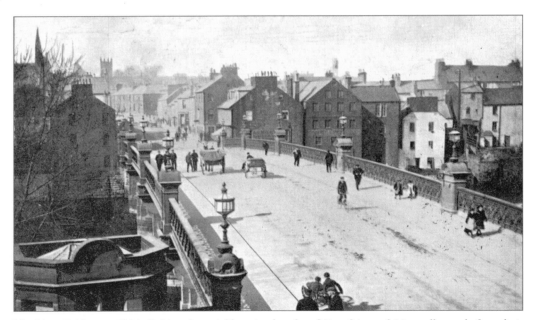

The New Bridge, *c.* 1904, linking the neighbouring burghs of Dumfries and Maxwelltown before their amalgamation in 1929. The enormous weight of traffic sustained by this bridge in recent years, not least a constant procession of container lorries making for the Stranraer–Larne ferry, has been considerably eased by the opening of the town's by-pass.

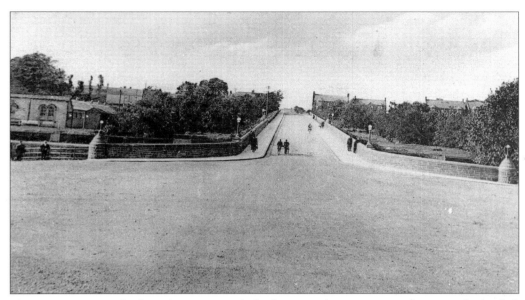

The entrance to St Michael's Bridge, *c.* 1947. The bridge, opened twenty years earlier, was a further link between Dumfries and Maxwelltown before the two burghs amalgamated. As a contemporary report in the *Dumfries and Galloway Standard* explained, an estimated ten thousand people gathered here in October 1929, to watch the Duke of Buccleuch open a ceremonial gate 'symbolically removing all barriers to union'.

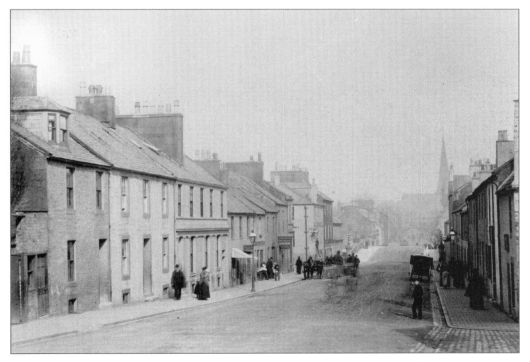

Looking down Galloway Street towards Buccleuch Street in 1893. This is another photograph taken by John Rutherford who was, at the time, the official photographer to Dumfries Prison.

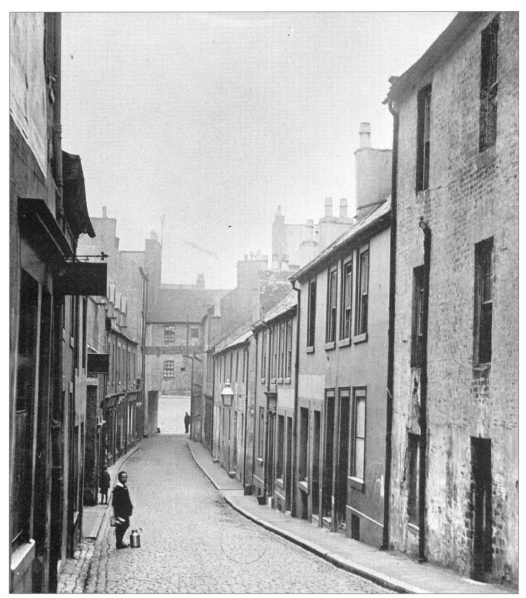

The Wide Entry (demolished during the 1920s to make way for Great King Street), looking down towards High Street from Loreburn Street.

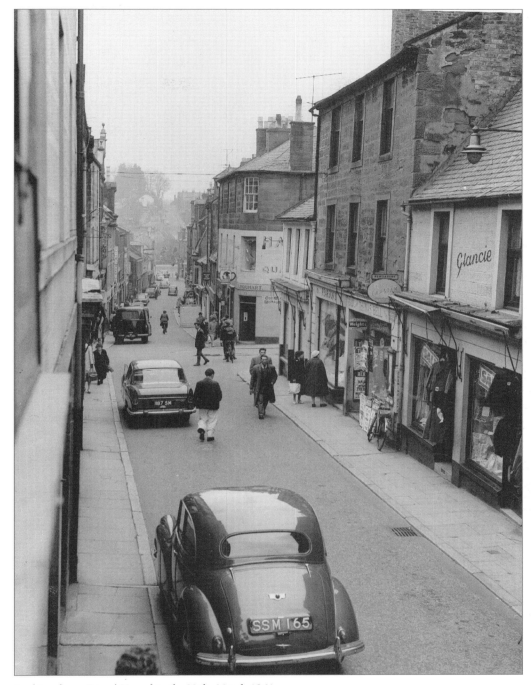

Looking down Friars' Vennel to the Nith, March 1961.

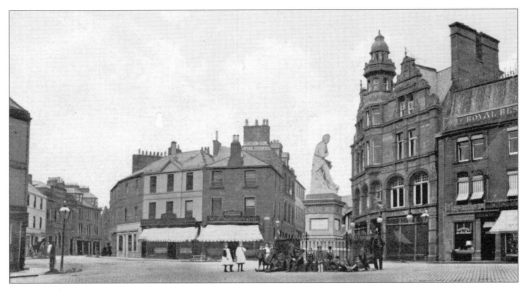

The Burns Statue, looking towards Church Crescent, *c.* 1914. Fashioned in marble and designed by Amelia Hill, the statue was financed by public subscription and unveiled in 1882. Over the years it has been slightly re-sited to make way for road alterations but its dominant position, commanding the High Street, is testimony to the special place that Burns occupies in the life and history of the town.

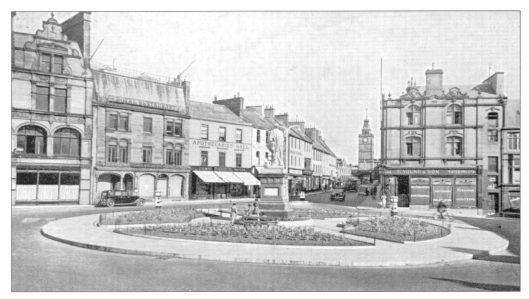

In May 1938, the Burns Statue came to rest in its present position. Here, as elsewhere in Dumfries, floodlighting was added in 1986, as a lasting reminder of the town's Octocentenary Year celebrations, marking the creation of Dumfries as a Royal Burgh in 1186.

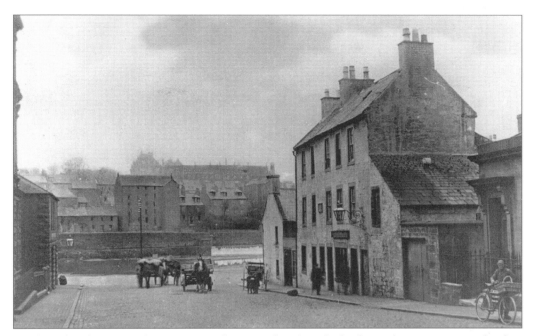

The foot of Bank Street with not a car in sight – just a bicycle and a few horse-drawn carts. Burns lived on the first floor of the tenement on the right, when he first moved to the town in November 1791. The flat is now privately owned.

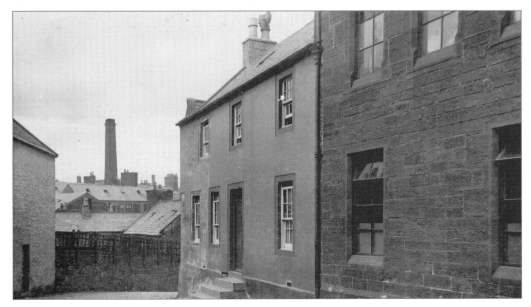

Burns House in Burns Street, *c.* 1905. The poet lived here from May 1793 until his death in July 1796. Nowadays the house (which is next door to the town's modern Activity and Resource Centre) is open to the public, and has become a literary shrine for anyone interested in Burns' life and work.

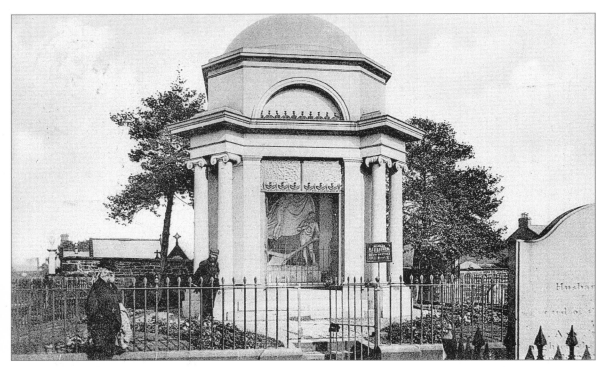

The Burns Mausoleum in the south-east corner of St Michael's churchyard, *c.* 1906. The foundation stone of this Grecian temple-style tomb, designed by T.F. Hunt of London, was laid on 6 June 1815, although the Mausoleum was not finally completed until several years later. The poet's remains were interred here in 1815, after being conveyed with enormous care and reverence from their original resting place in the north-east corner of the graveyard. Burns' widow, Jean, and other members of the family, were also buried in the Mausoleum, which is an essential port-of-call for anyone following the town's 'Burns Trail'.

The Globe Inn has been a hostelry since 1610 and it was, of course, Burns' favourite 'howff'. Although minor changes have been wrought on its exterior in the meantime the building, as it stands today, is instantly recognizable in this photograph of nearly a century ago.

Turn-of-the-century Henry Street, just a stone's-throw from the Burns Mausoleum. The house glimpsed here is typical of those to be found in many of the town's fine sandstone terraces.

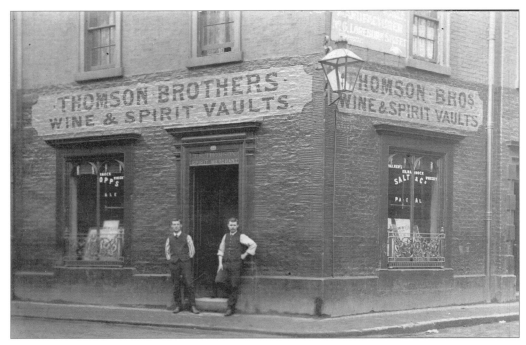

Thomson Brothers' Wine & Spirit Vaults on the corner of Loreburn Street and English Street, seen here at the turn of the century.

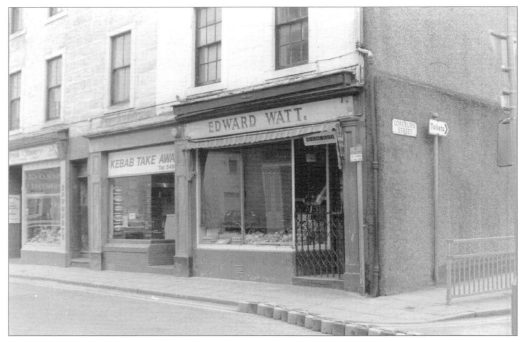

The same corner nearly seventy years later. Edward Watt, grocer, was the town's Provost from 1960 to 1965.

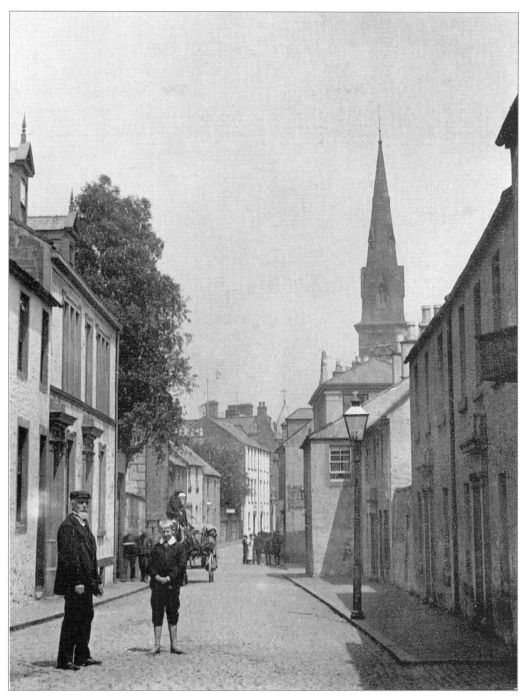

Shakespeare Street at the beginning of this century. The lofty roof of Scotland's oldest working theatre, the Theatre Royal, can be glimpsed on the right. J.M. Barrie said of the building, opened in 1792, that it was '. . . so tiny that you smile to it as a child when you go in'.

Pre-1920s Gasstown; an area of Dumfries named after Joseph Gass, who contributed so generously during the early nineteenth century to the development of this once separate village.

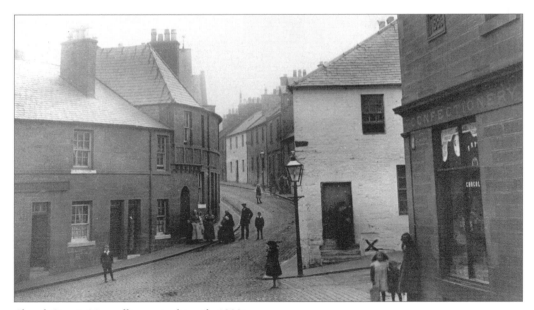

Church Street, Maxwelltown, in the early 1900s.

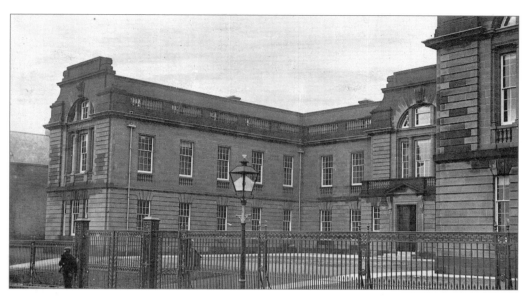

The County Buildings, latterly the Regional Council Offices, in English Street, which were erected between 1911 and 1915. This photograph must date from before 1935, the year in which the Queensberry Monument was moved here. The Monument was returned to its original site, Queensberry Square, after that part of the town was pedestrianized in 1990.

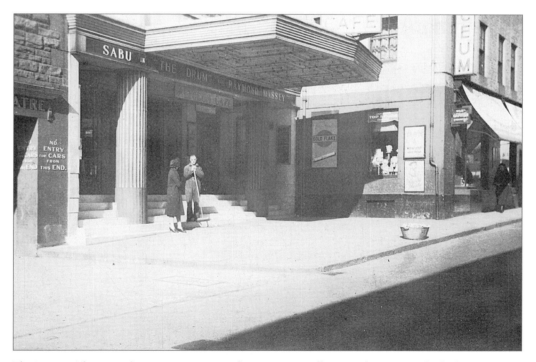

The Lyceum Theatre and Picture House in High Street (originally erected in 1911 and rebuilt in 1936), is seen here in the early 1960s towards the end of its life, and during a week when *The Drum*, starring Sabu, was making yet another return to delight the cinema-going public of Dumfries.

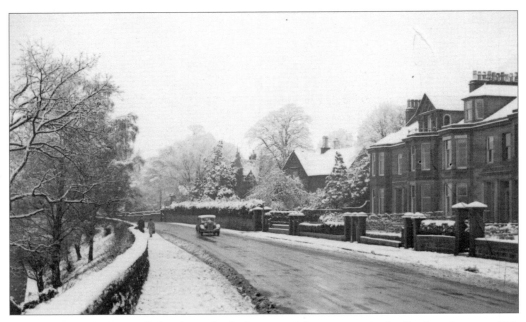

Snowbound Langlands on Edinburgh Road, which is one of the main arteries leading into the town. This photograph is undated, but it may well have been taken during the harsh winter of 1947.

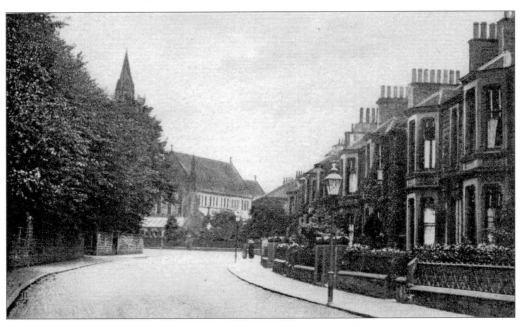

Lovers' Walk and St John's Episcopal Church between the wars. Apart from the gas lamp and an absence of traffic, this leafy, attractive road is surprisingly little changed today.

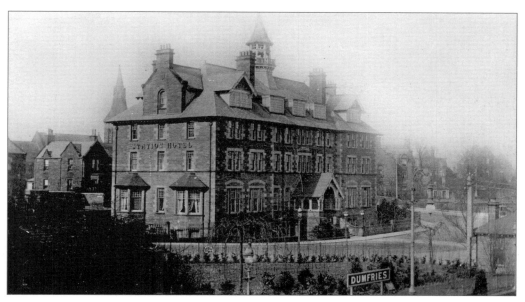

The late-Victorian splendour of the Station Hotel, built in 1896. Many of the original internal features can still be seen, including ornate cornices and ceilings and a fine staircase. The building has altered little externally since this photograph was taken over fifty years ago.

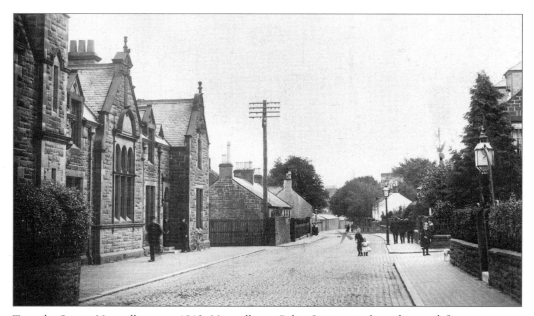

Terregles Street, Maxwelltown, *c.* 1912. Maxwelltown Police Station stands on the near left.

Calside Sanatorium on Craigs Road was built in 1905, in response to a smallpox scare in Dumfries. In the event, however, it was destined never to receive a single smallpox patient, and so the building later served as a TB hospital until the opening of Lochmaben Sanatorium. Long since derelict, it was demolished in the early 1970s.

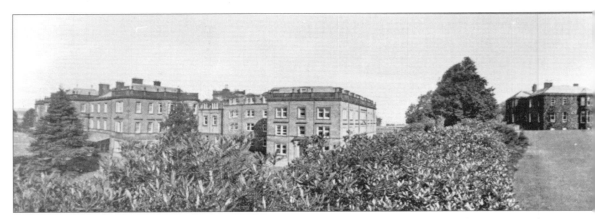

An easterly view of the Crichton Royal Hospital, taken by a former patient during the 1930s. Crichton House, seen on the extreme right and now called Campbell House, is the home of West Sound Radio. Named after its benefactor, Dr James Crichton, and opened in 1839, the Crichton Royal Institution quickly established an enviable worldwide reputation for its enlightened treatment of mental illness. During the late nineteenth century it accommodated around one thousand four hundred patients, although that number has now dropped to below three hundred. Served by its own artesian well, the hospital has always been self-sufficient in water. Now, with fewer patients, there is water to spare and so it is bottled and sold. The Crichton's extensive and well-kept grounds remain one of the town's most pleasing features.

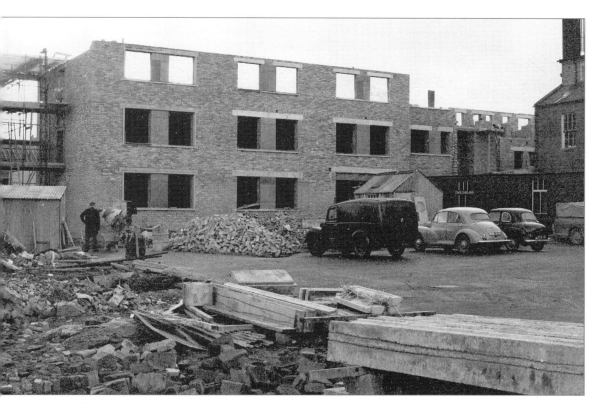

Cresswell Maternity Hospital, constructed on and around the site of the town's former Poor House, was built in three phases and eventually completed in 1968. This photograph, taken in about 1956, shows the first phase of building.

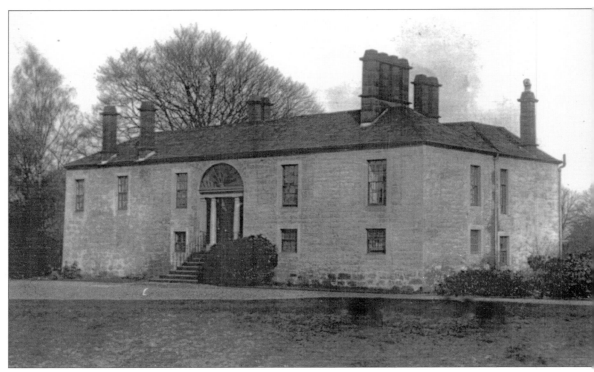

Elegant and well proportioned, Tinwald Downs House was taken over by the RAF in 1938 and subsequently demolished to make way for the airfield. RAF Dumfries, sometimes unofficially known as RAF Tinwald Downs, specialized in the training of navigators and air-gunners and – like ICI – was sited locally in the hope that it would be less prone to enemy attack. Constructed in 1939 on the site of the old racecourse, the airfield was in use until 1957 and the land was sold three years later. Nowadays, Dumfries Aviation Museum, opened in 1977 and run entirely by volunteers, is housed in a wartime control tower on the site. It attracts around four thousand visitors annually from all over the world.

ALL WORK . . . AND SOME PLAY

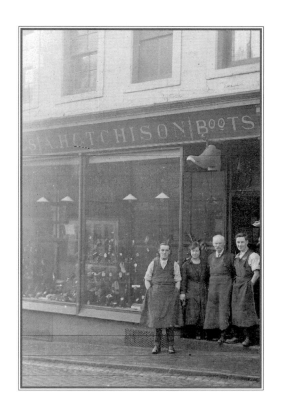

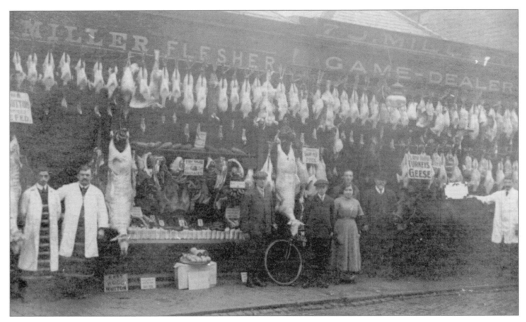

Environmental Health Inspectors would have a field day here. But this scene, outside Miller the Game Dealer's Irish Street premises in 1913, is typical of its period, with poultry, game and carcasses of lamb and beef on open-air display at the mercy of the elements. Many would claim, in this age of shrink-wrapped freezer packs, that we have simply exchanged one set of hazards for another.

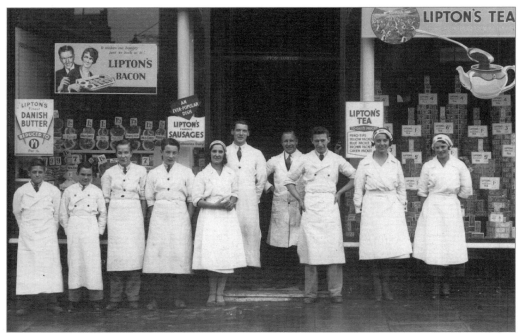

Liptons, in Queensberry Square, was one of those well-managed grocery chains that established itself in countless towns up and down the country. Own brand butter was just 1s 1d per lb when this photograph was taken in the 1940s.

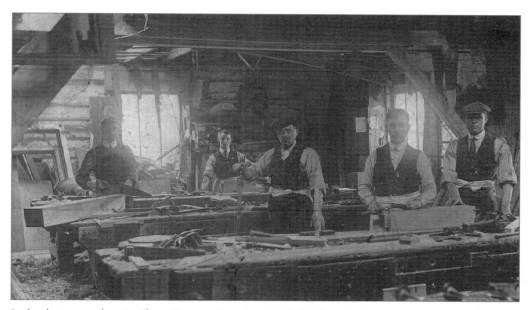

Jardine's joinery shop in Three Crowns Court, *c.* 1913. William Jardine, Joiner & Undertaker, was established in 1899 (although an earlier family firm, James R. Jardine, was started in 1862 and collapsed following the notorious Glasgow Bank's crash). William Jardine has always operated from Three Crowns Court as a combined joinery/undertaking business, although nowadays the two sides of the firm are based on separate sites in different parts of the town, with the undertaking business remaining at Three Crowns Court.

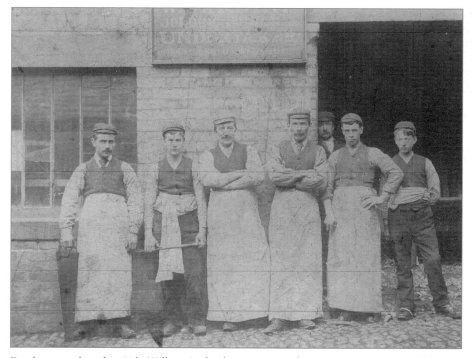

Employees gathered outside William Jardine's premises in Three Crowns Court, *c.* 1919.

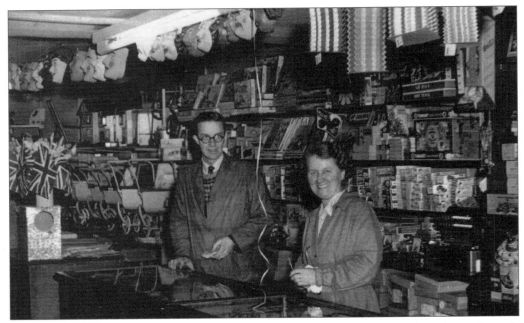

John Hamilton Newall and his wife, Rose, behind the counter of their Friars' Vennel toy shop in the early 1950s. Opened (originally in High Street) in 1946, Newall's is now the town's only independent toy shop, and run by the founder's daughter and son-in-law, Mr and Mrs Wise.

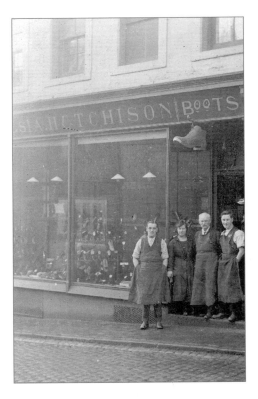

Photographed outside their Nith Place premises in the 1930s, A. Hutchison & Sons was one of the town's notable clog-making families. During the 1970s, John Hutchison passed on some of his knowledge to Godfrey Smith, a present-day clog-maker working at Balmaclellan.

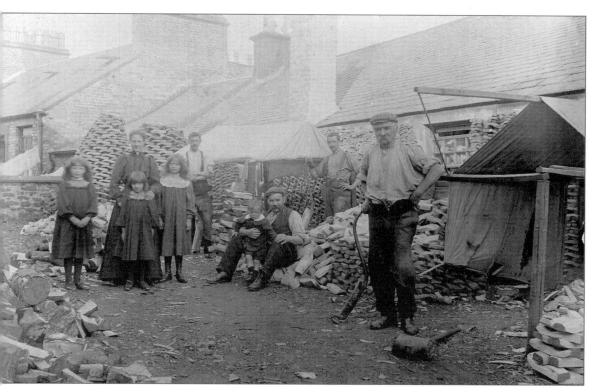

An unusual rear view of Friars' Vennel, showing the back yard of John Grierson's clog-making business – 'Grierson's Station', as it was known, *c.* 1902. John Grierson (sitting with his son, Robert, on his knee among stacks of clog soles) later moved to Queensberry Street but, in 1933, the next generation of Grierson clog-makers returned to Friars' Vennel when another of John's sons, Tommy, established his one-man firm there after his father's death. Tommy made many radio and television appearances explaining his craft, before he died in the early 1970s. John Grierson was not only the driving force behind one of Dumfries' two clog-making dynasties, he was also founder-director of the town's much cherished football team, Queen of the South.

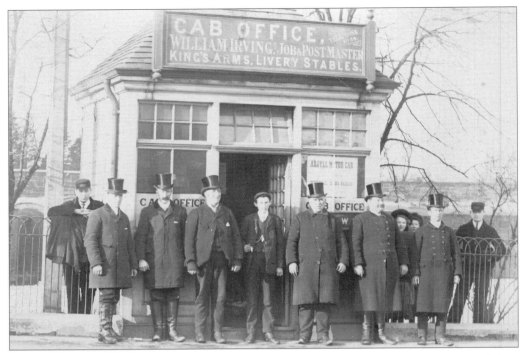

Top hats were all the rage at Dumfries station's cab office around ninety years ago. It is an item of dress not often seen amongst taxi-drivers waiting in the station forecourt today!

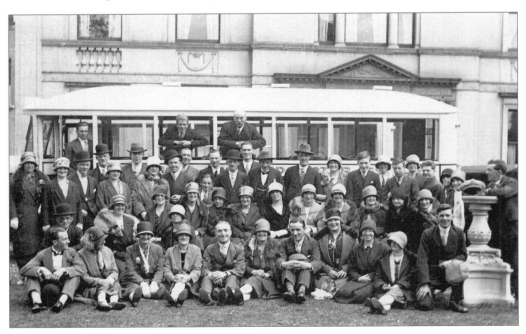

A day off. The Lyceum Theatre staff outing to Ayr, 26 June 1927. Perhaps it was a typically chilly summer, and Ayr can certainly be bracing but, nevertheless, a surprising number of fur-trimmed heavy outdoor coats are in evidence amongst the female members of the party, for the time of year.

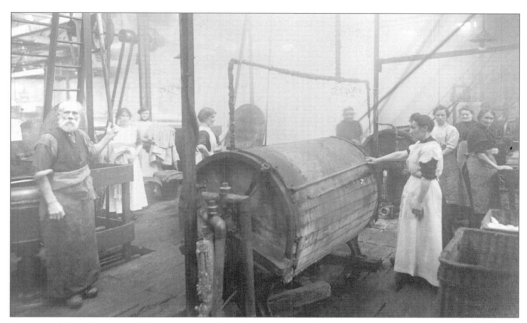

Shortridge Launderers and Drycleaners before the turn of the century. The company was established in 1845 by a Dumfries man, Thomas Shortridge, who was a pioneer of modern-day cleaning techniques. He rapidly built up a unique reputation for innovation, quality and service throughout the United Kingdom and many discerning clients, including leading figures of stage and screen, insisted that their laundry and dry cleaning requirements were only processed by Shortridge of Dumfries. The company thrives to this day.

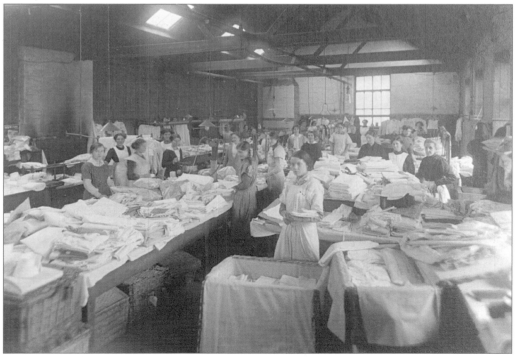

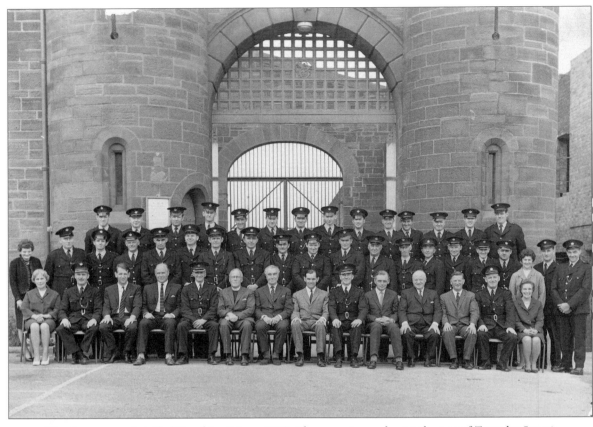

The Governor and staff of Dumfries Prison, 1968. The present complex (at the rear of Terregles Street) includes a Young Offenders' Institution, and replaces an earlier prison situated in Buccleuch Street. Inmates, some of them serving life sentences, are drawn from all over Scotland. When the existing prison opened in 1883 it was surrounded by fields, but now it has been engulfed by the town. However, it enjoys excellent relations with the surrounding community.

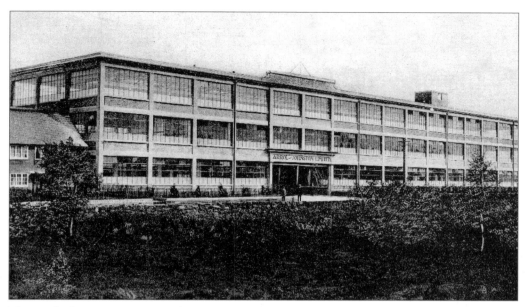

The Arrol Johnston motor car production works at Heathhall, which opened in 1913 when the company moved from Paisley, and which was once described as 'a little Detroit by the Nith'. Production ceased in 1931. Nowadays, of course, these premises are occupied by the Gates Rubber Company.

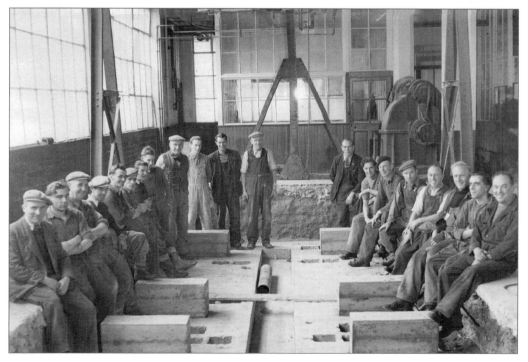

This photograph was catalogued as 'Arrol Johnston workforce c. 1935'. Given that the company had gone into liquidation several years earlier, it provides an unwelcome dilemma for the compiler of such a book as this. Several light engineering firms occupied the former Arrol Johnston works during the 1930s.

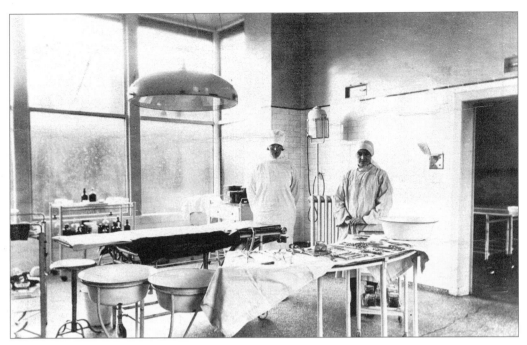

Operating theatre at Nithbank, *c.* 1929. Founded in 1776, the town's infirmary was only the fourth to be established in Scotland. The present modern complex was opened in July 1975.

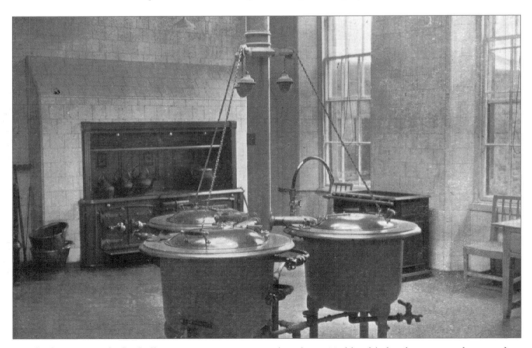

No doubt a great deal of elbow grease was required to keep Nithbank's kitchens in such a spotless condition during the 1930s. Nithbank was the third of the town's four successive infirmaries to be built over the years.

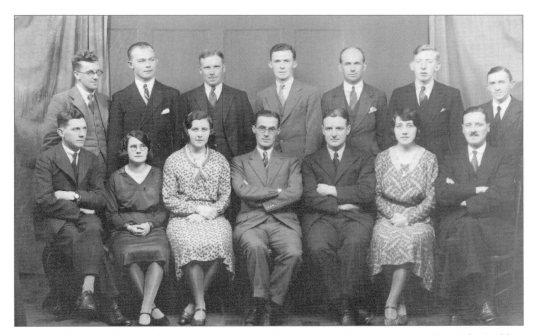

Managerial staff of the Dumfries County Council Electricity Supply Company, *c.* 1930. John Pickles, (third right, front row), later knighted and Chairman of SSEB, was the Deputy County Electrical Engineer for Dumfriesshire at the time of this photograph.

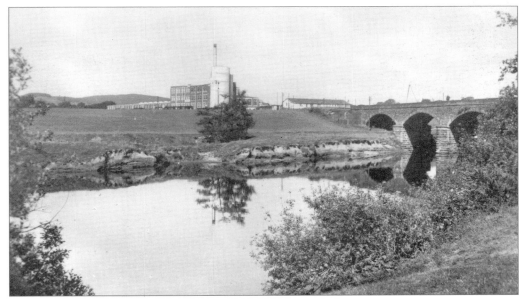

A pastoral air pervades this view across the Nith looking towards the Carnation factory, built in 1935. Today the plant (which forms a part of the Nestlé empire), stands in the shadow of the busy Dumfries by-pass.

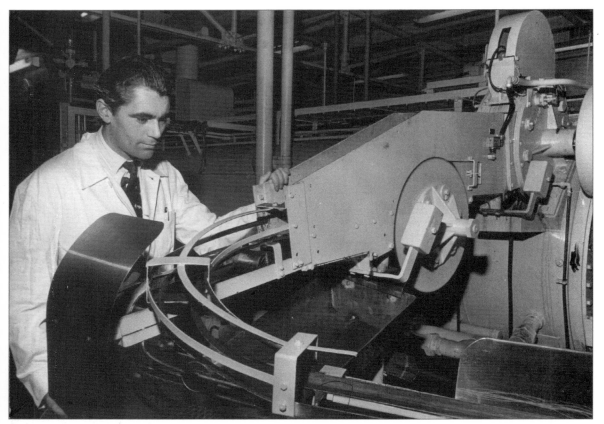

Quality Controller Hugh Wilson inspects a can coming off the production line at the Carnation factory in 1965, in a part of the works that was closed down a few years ago. Latterly, until his retirement in the spring of 1996, Hugh Wilson has been Regional Trade Group Secretary for the Agricultural and Rural Section of the Transport and General Workers' Union, for the whole of Scotland.

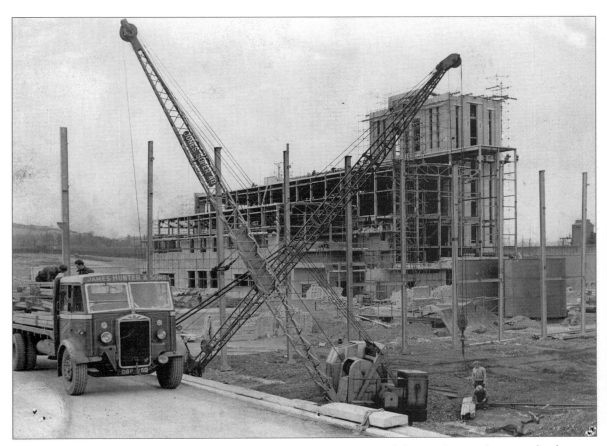

Construction work in progress during 1950, for what remains one of the town's most distinctive local landmarks: the ICI plant at Cargenbridge. ICI arrived on the edge of Dumfries at the beginning of the Second World War because rural, thinly populated south-west Scotland was regarded as a relatively safe environment for the company to make its contribution to the war effort. Initially a munitions factory making gunpowder, the complex was extended ten years later, in 1950, to take on the manufacture of newly developed Ardil, a synthetic fibre made from groundnut waste that was quickly overtaken in popularity by nylon and terylene. The Ardil project closed down in the late 1950s and the company, re-styled as ICI Films, now produces Melinex and Propafilm. At its peak, ICI employed around 2,000 people on this site, but today the workforce is less than half that number.

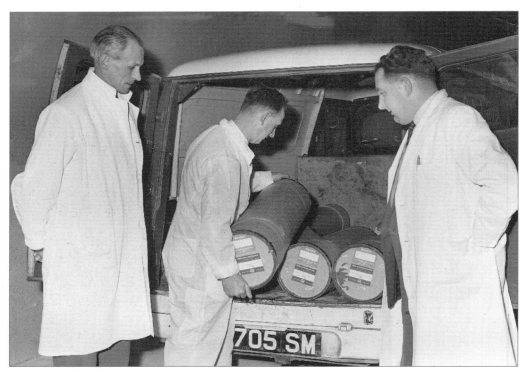

(Left to right) Ernie Hann, Jack Cunliffe and Alan Biggs supervise the first dispatch of Melinex film from the ICI plant, in 1961.

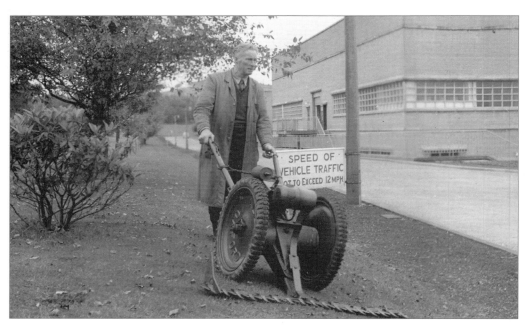

Gardener Tam McQuillan keeps well within the modest speed limit, while manicuring the grass verges at ICI during the late 1960s.

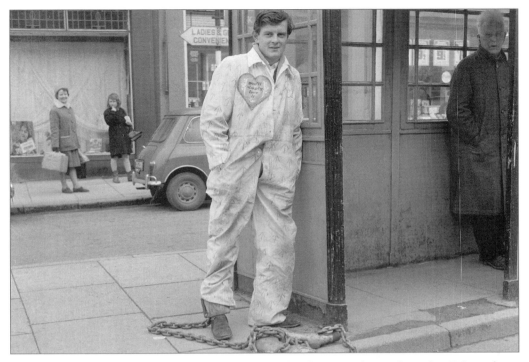

ICI apprentice Tom Howat draws enquiring glances at the Plainstanes during the early 1970s, and it is hardly surprising when you consider the hook and chain anchoring him to the 'bus-shelter. Apparently, it was all part of a pre-wedding apprentice tradition.

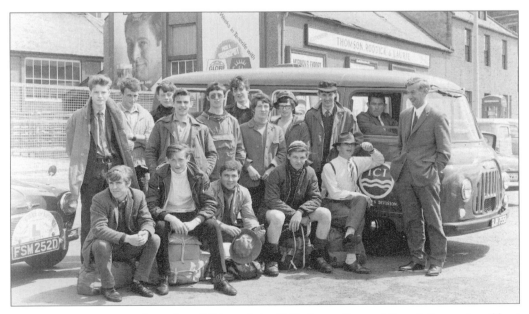

ICI apprentices prepare to leave from Whitesands in 1967, for an Outward Bound Course (possibly at Eskdale in the Lake District). By all appearances, several members of the group seemed blissfully unaware of the rigours that lay in store for them.

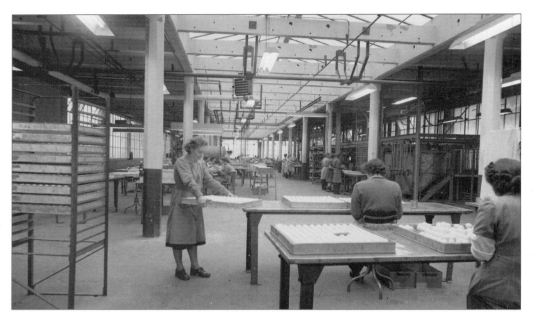

It would be interesting to know what percentage of the balls employed in the world's major golfing tournaments started life at Uniroyal in Heathhall, seen here during the early 1960s. Production ceased during the 1970s and, subsequently, golf balls were manufactured by Abernethy's in Locharbriggs, until that firm closed just a few years ago.

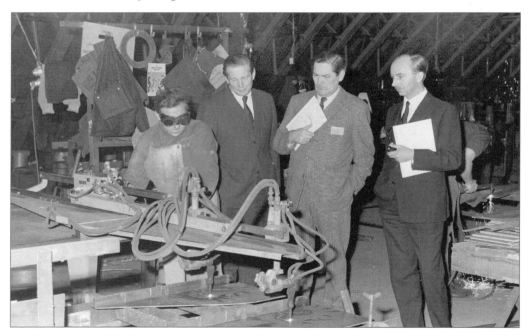

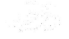

Local Conservative MP, Sir Hector Monro (second left) tours Penman's new steel fabrication plant after formally opening it on 27 November 1970. Sir Hector, who has represented the local constituency for over thirty years, will be retiring from the House of Commons at the General Election due to be held in 1997.

WAR . . . AND PEACE

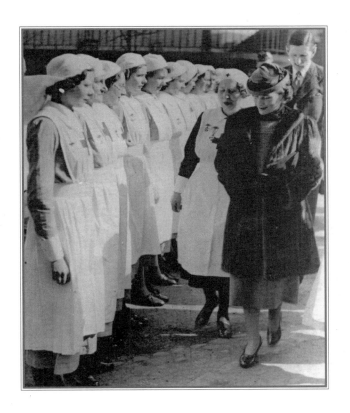

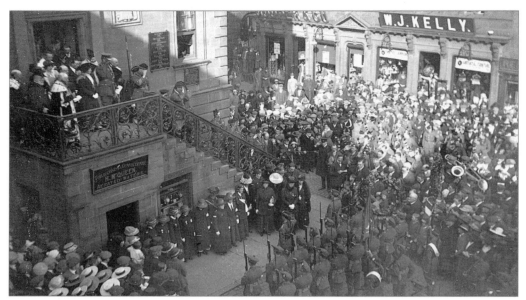

The Duchess of Buccleuch, accompanied by the town's Provost, Thomas Macaulay, and other dignitaries, welcomes home local regiment the King's Own Scottish Borderers after the First World War, at a well-attended ceremony held around the Midsteeple.

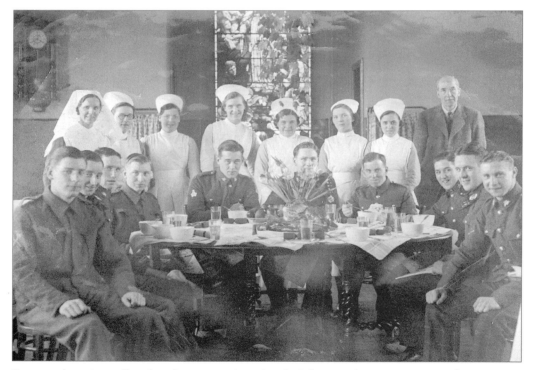

Troops and nursing staff, gathered in a surgical ward at the Infirmary after D-Day 1944, with Sister Jessie Maxwell standing on the extreme left.

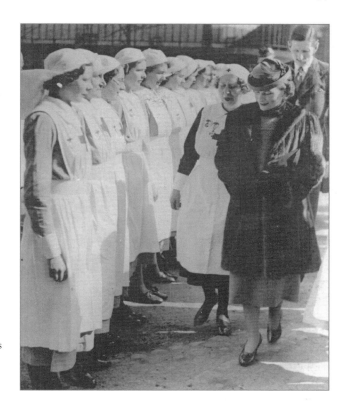

The Duchess of Gloucester paying a
wartime visit to the town's Red Cross
Headquarters, and passing along the
ranks of Dumfries 34 Voluntary Aid
Detachment (VAD).

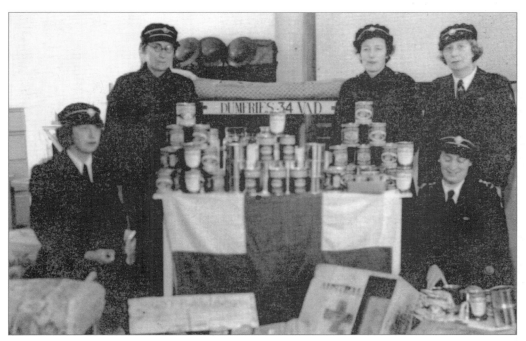

Members of Dumfries Red Cross (34 VAD) display food parcels sent by their Australian counterparts and
destined for British prisoners of war.

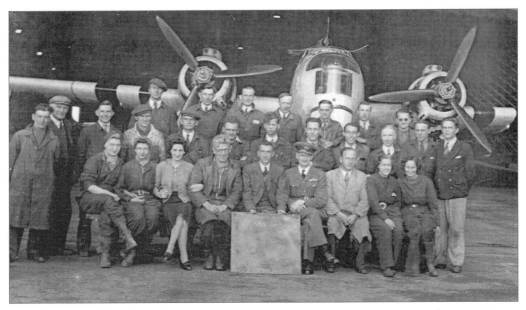

A Coastal Command Wellington, and the civilian workforce that serviced it at RAF Dumfries, *c.* 1944.

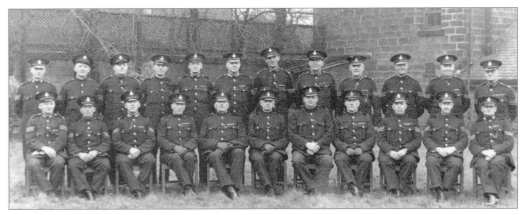

At the risk of being put on a charge, one is tempted to ask who was actually guarding the perimeter fence while this impressive contingent of Second World War Military Police personnel gathered for their group photograph at RAF Dumfries.

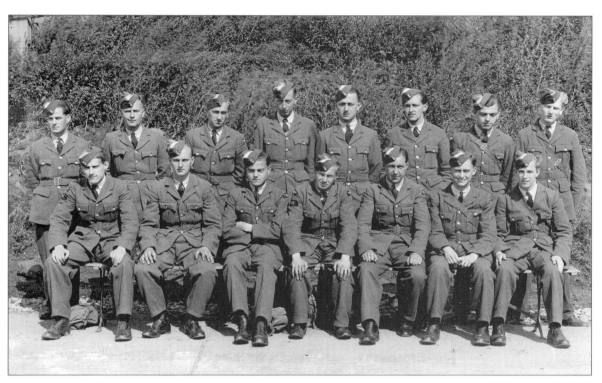

Members of just one of the many air gunners' courses held at RAF Dumfries during the Second World War. This photograph, probably taken in 1940, shows (back row, fourth from left), local man Humphrey Knipe, who was later lost in action. According to one assessment, only about 15 per cent of the trainee navigators and air gunners who passed through RAF Dumfries actually survived the war unscathed.

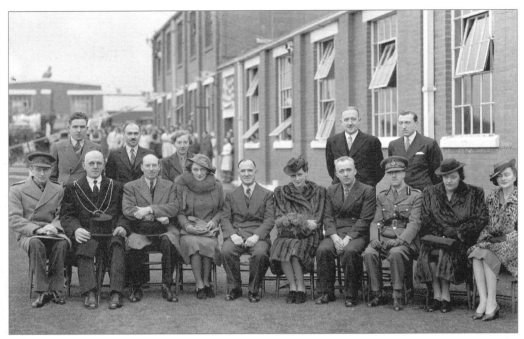

The Duchess of Kent (Princess Marina), during a morale-boosting wartime visit to the Carnation factory. Douglas Rogers, the firm's manager, is seated on her left. Always famous for her poise and elegance, the Duchess is wearing one of the 'Marina' hats that were particularly associated with her.

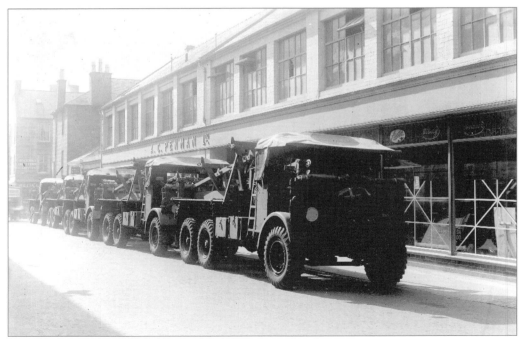

Ready for action. A fleet of army vehicles, with bodywork by Penman, line up outside the firm's premises in Irish Street during the early 1940s (on the present site of 'What Everyone Wants').

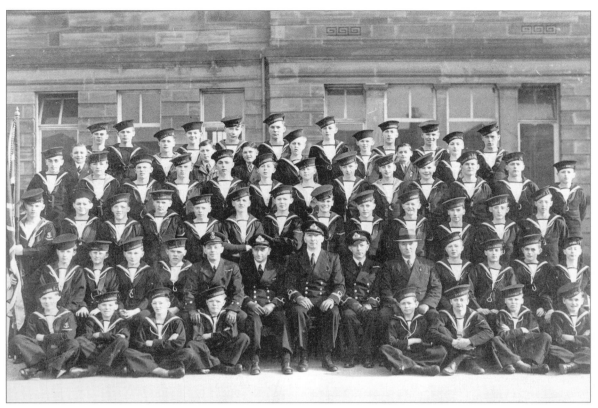

Sea Cadets pictured outside Dumfries Academy, their regular weekly meeting-place, after a training session in 1942.

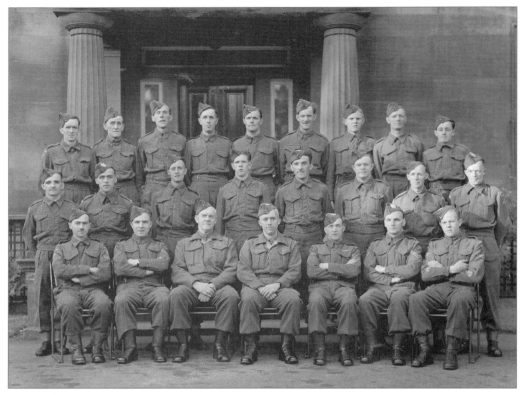

For any fans of BBC TV's *Dad's Army*, the urge to search for a Captain Mainwaring or Private Godfrey look-alike among the members of this Carnation factory wartime Home Guard platoon is entirely irresistible.

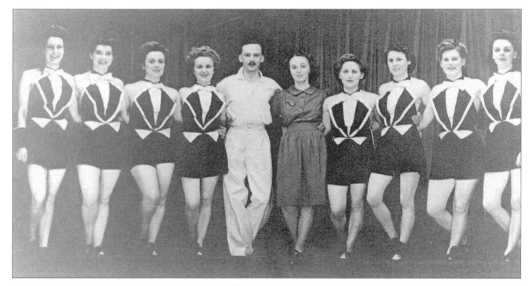

No, it isn't Bruce Forsyth and an early Tiller Girls troupe, but a wartime WAAF concert party, performing on stage at the Lyceum for the airforce personnel stationed at RAF Dumfries.

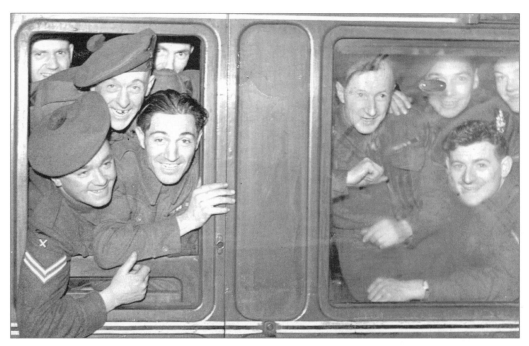

Even tinned sardines have more elbow-room than this tightly packed bunch of King's Own Scottish Borderers. However, their faces say it all as they leave Dumfries by train, bound for the Victory Parade in London at the end of the last war.

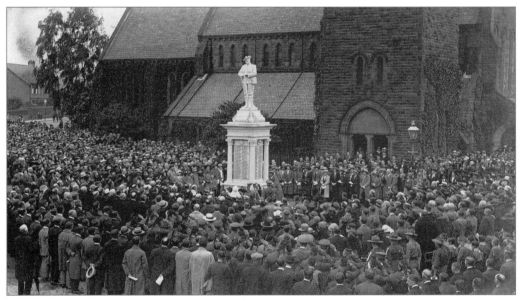

A huge crowd gathers outside St John's Episcopal Church in Lovers' Walk, to witness the unveiling of the Dumfries War Memorial, *c.* 1922.

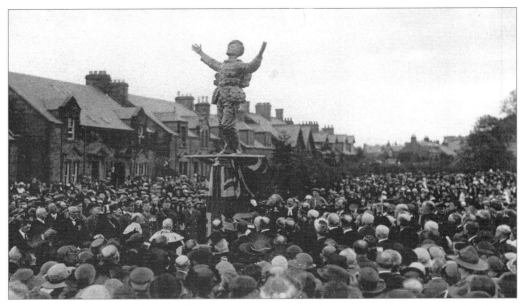

The unveiling ceremony of Maxwelltown War Memorial, at the junction of Rotchell Road and New Abbey Road, in November 1920.

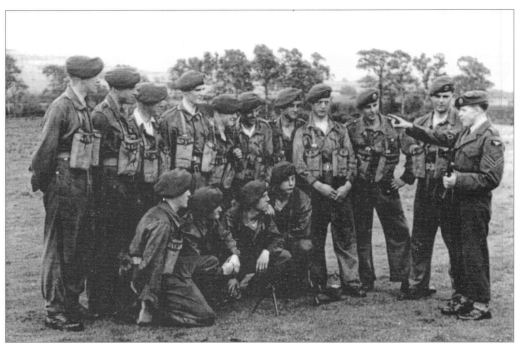

The war may be over, but there could well be a few battles ahead (not least with their sergeant) for these youthful early-1950s conscripts at RAF Dumfries during the dying days of National Service.

TRANSPORT

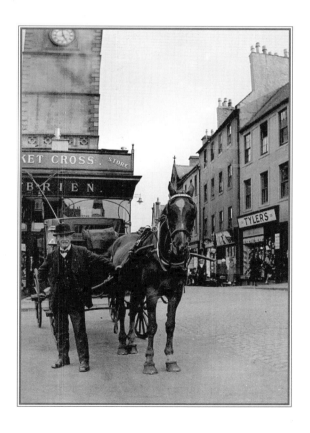

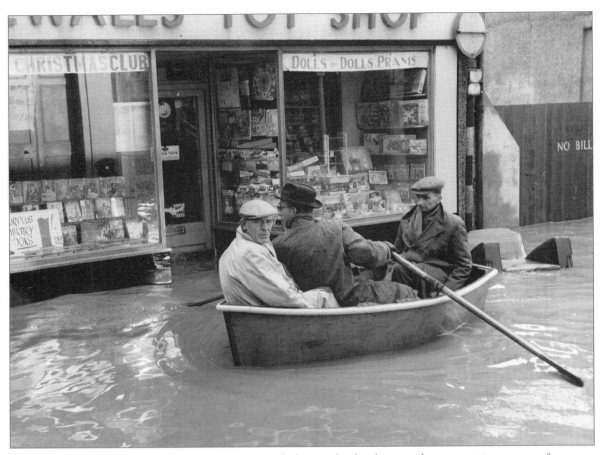

I doubt if this was quite what Jerome K. Jerome had in mind, when he wrote his entertaining account of a leisurely summer expedition down the Thames, in *Three Men in a Boat*. Here, only the dog Montmorency is missing as a trio of intrepid fugitives from the overflowing Nith row uncertainly past Newall's toy shop in Friars' Vennel during the early 1960s.

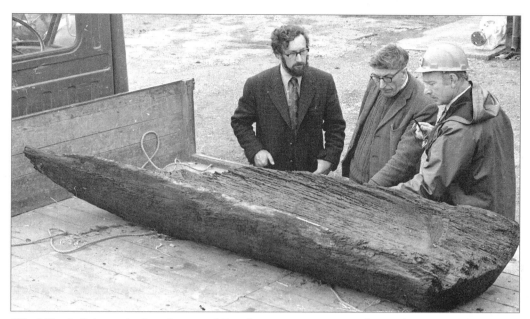

Alfred Truckell (centre), then Curator of Dumfries Museum, contemplates a fragment of an iron-age canoe (found close to the Lochar on Catherinefield Farm near Locharbriggs), on its arrival at ICI in the early 1970s, where it was to be deposited in a preservation tank. The fragment is now housed in the Museum.

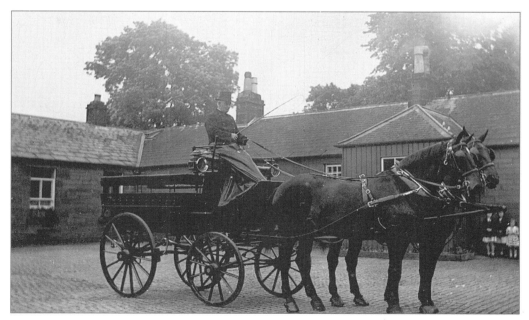

The distinguished figure of James Hollis Girling, coachman at the Crichton Royal Hospital, pictured here in 1920. He retired in the late 1940s and died in 1965, aged ninety-two.

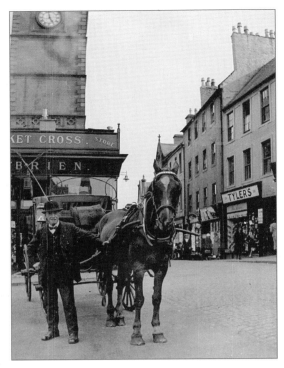

Adam Graham, seen here waiting below the Midsteeple for his next fare. He was once a familiar sight on the streets of Dumfries, and known as the 'Lone Cabbie' because he operated the town's last horse-drawn taxi service. He died in 1958, aged ninety.

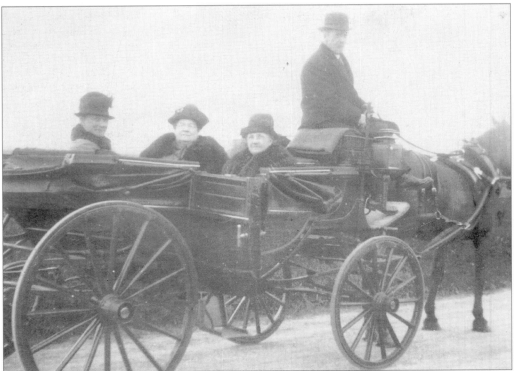

Adam Graham at work.

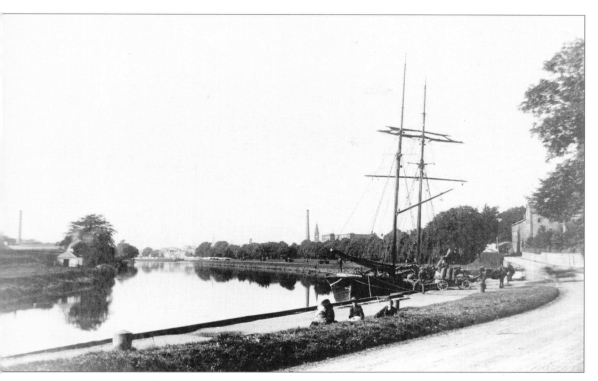

It is sometimes easy to forget that Dumfries was once a thriving port, doing considerable business mostly in imports (such as coal from Cumberland and tobacco) until the mid-nineteenth century, after which trade steadily declined. There were a number of quays along the Nith between Glencaple and the town itself, so that by 1893 it was fairly unusual to see a vessel as large as the 65-ton 'Dolphin' (seen in this photograph) at Dockfoot, unloading a consignment of grain for Castlebank Mill. More often than not, cargo was put ashore at Kingholm or beyond, then taken by road into the town. The last ship berthed at Dockfoot in 1916.

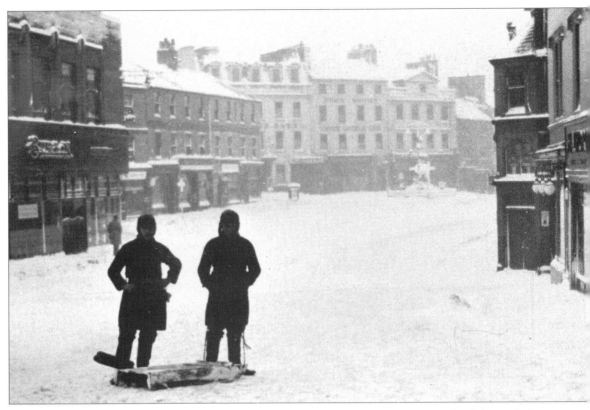

Deep snow invests most landscapes with a timeless quality, as in this photograph of the High Street looking towards its junction with English Street in the 1930s. Who are the two silhouetted figures, I wonder, posing with their home-made sledge? (It was the only way to travel in the circumstances!)

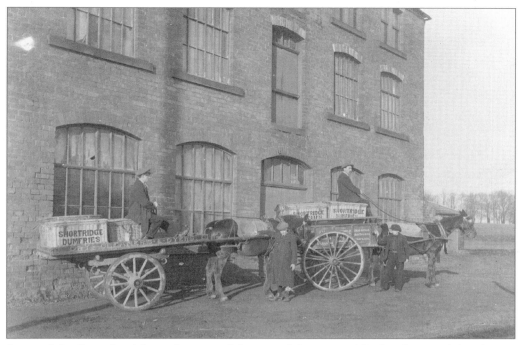

A part of the Shortridge delivery fleet around the turn of the century. The launderers and dry cleaning company built up such an enviable reputation that it soon became necessary to establish a nationwide delivery service.

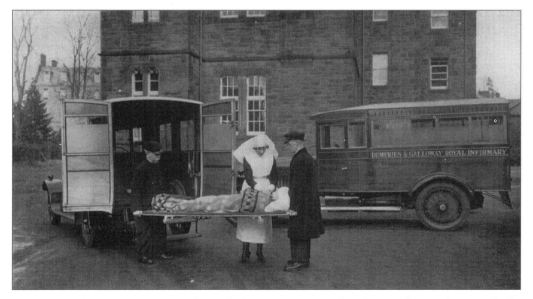

Thankfully, ambulances have improved out of all recognition since this photograph was taken outside the Infirmary during the 1930s.

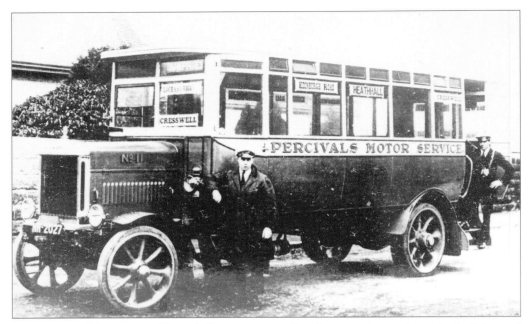

Percivals of Carlisle was one of the early 'bus operators in Dumfries, running services to Locharbriggs and other local destinations during the 1920s.

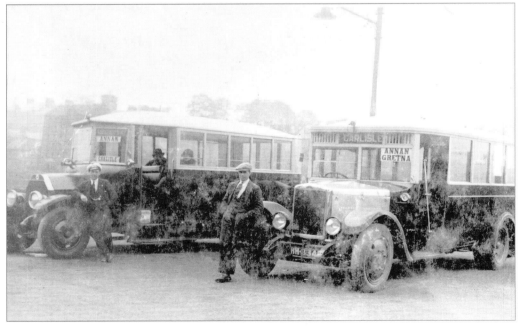

Competition was fierce in the 1920s and '30s, with several 'bus proprietors operating vehicles on important routes, for example the one from Dumfries to Carlisle. Here, two 'buses belonging to Farrer and Faulder of Carlisle await their passengers at Whitesands, *c.* 1930.

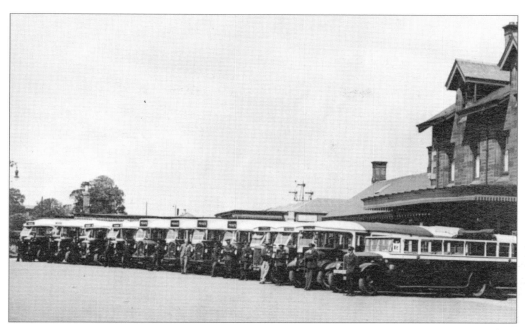

This impressive row of coaches belonged to the Caledonian Omnibus Company, a prominent public transport operator in the area during the 1930s and '40s. The vehicles are waiting outside Dumfries station in about 1933, to take passengers on a short tour probably of the Solway coast.

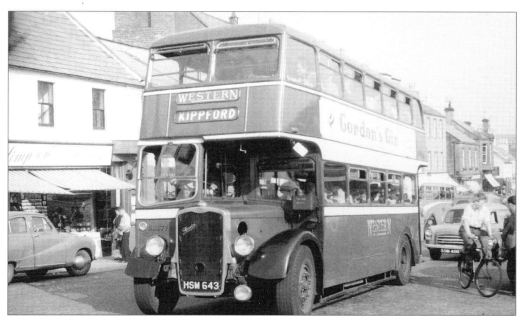

A Bristol double-decker belonging to Western SMT of Kilmarnock, which took over from Caledonian in 1949, leaves Whitesands during the late 1950s bound for Dalbeattie and Kippford.

The demise of the two-person 'bus crew will bring a tear even to a glass eye; not least because most of us, at one time or another, will have sat in our cars queueing and fuming behind a one-man operated 'bus, while the hapless driver or conductor searches for dropped coins or tinkers with a jammed ticket machine.

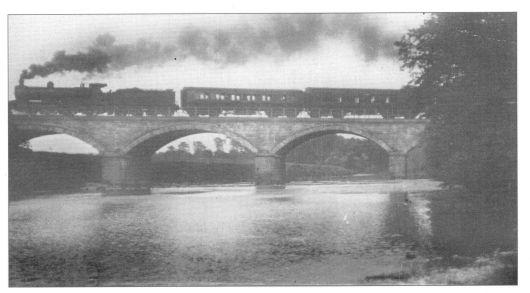

An undated photograph of the London and Glasgow express crossing the Nith on Burns' Walk Bridge, on the old Glasgow and South-Western route.

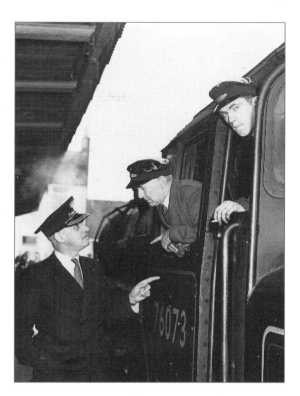

Dumfries station glimpsed in the age of steam, with relief station-master Jim Cluckie and engine driver Albert Rogerson. In 1986 and 1987, Dumfries was voted Scotrail's 'Best Kept Station', and received the 'Station of the Year' award again in 1995, in the competition judged by Beautiful Scotland in Bloom.

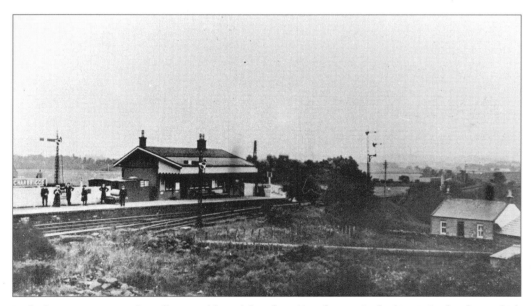

Locharbriggs station, on the sadly missed branch line from Dumfries to Lockerbie via Lochmaben, which was closed to passengers in 1952 and to goods traffic just over a decade later.

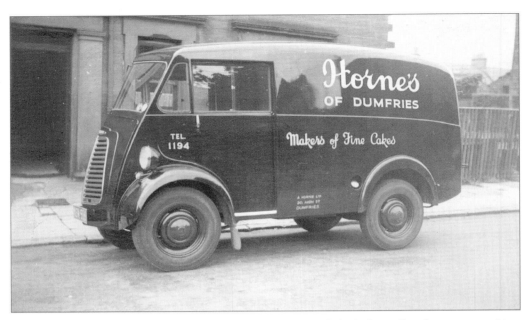

Between the 1930s and '50s, Dumfries supported around fifteen baker's shops all at the same time. Most – if not all – would have provided a door-to-door delivery service using vans of the type seen here (bearing wooden trays of fresh bread and cakes), belonging to Horne's of the High Street.

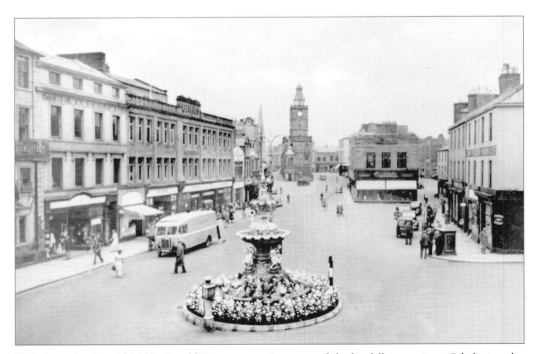

High Street in the mid-1930s. In addition to operating many of the local 'bus services, Caledonian also developed a prosperous parcel van and haulage business. One of their Albion vans is seen here delivering goods to Binns department store.

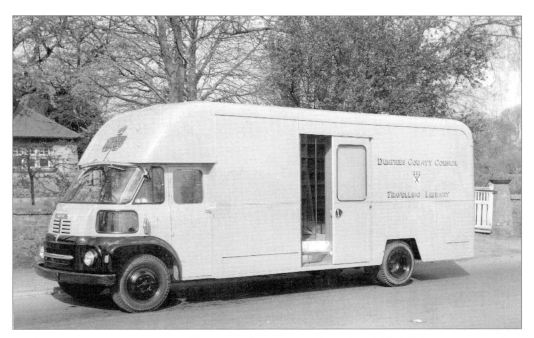

Rural communities everywhere would be much the poorer without their Mobile Library service, whose distinctive large vans reach out to the most scattered of hamlets and villages. Penman supplied the bodywork for this Dumfries-based vehicle of 1961.

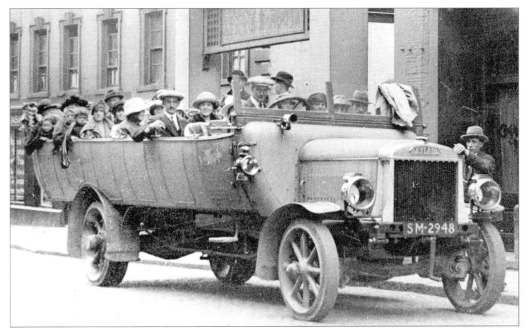

A 1920s' charabanc party prepares to leave town from outside the Lyceum. Perhaps it was heading for the nearby Solway coast which, with its headlands and secluded bays, has always been a popular area for a local day trip.

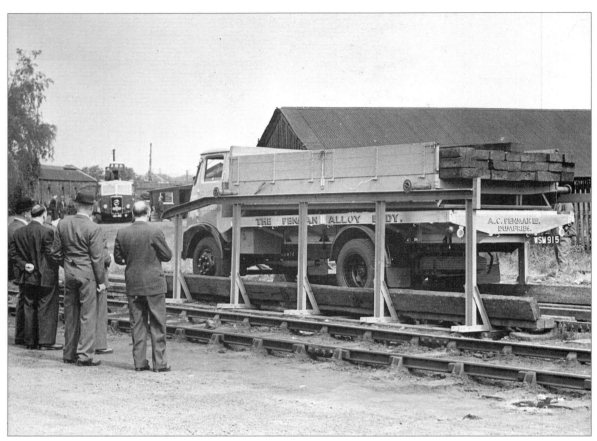

The time is the early 1950s, and the place is the old railway goods yard, roughly on the present site of Food Giant and its car park. The occasion was a demonstration of the Penman Patent Ramp. It is difficult to imagine our roads without the ubiquitous container lorry: the scourge of the motorways and the curse of our congested towns – although it has to be said that Dumfries was granted much relief on this score a few years ago with the opening of the by-pass. Penman's Patent Ramp facilitated the lifting of containers – tiny ones by today's leviathan standards – from the backs of lorries, thereby leaving the vehicle itself free for other uses, and allowing the container to be shipped separately by land, sea or air.

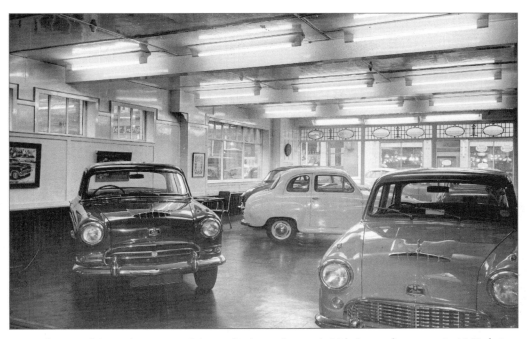

Just a glimpse of these gleaming models, on display at Penman's Irish Street showroom in 1962, brings those immortal words 'they don't make cars like that any more' rushing to the lips.

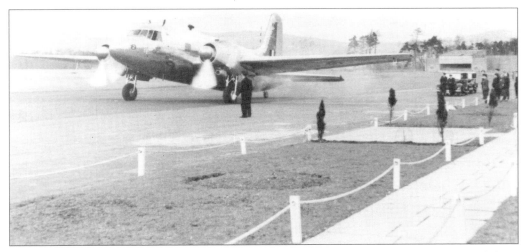

An aircraft of the Queen's Flight, with the Duchess of Gloucester on board, arriving at RAF Dumfries on 7 March 1953.

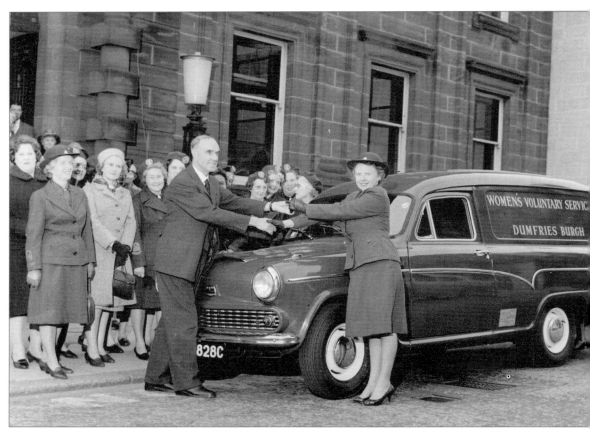

George Bartholomew, President of the Dumfries Rotary Club, presents local WVS organizer, Mrs L.T. Carnegie, with the keys of a new Meals-on-Wheels van, during a handing-over ceremony held outside the Municipal Chambers in Buccleuch Street in May 1965.

SPECIAL OCCASIONS

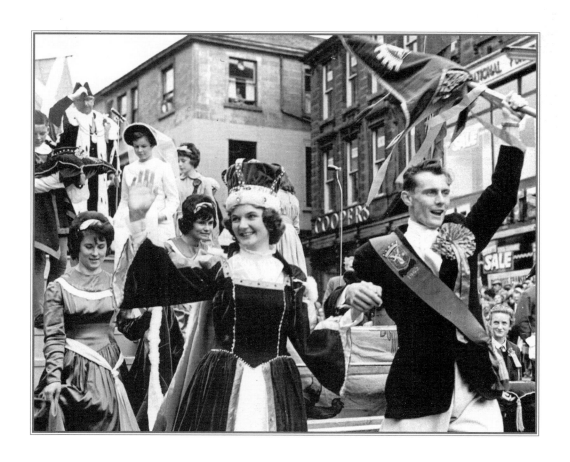

King's Own Scottish Borderers Recruiting Day in Dumfries, 1957.

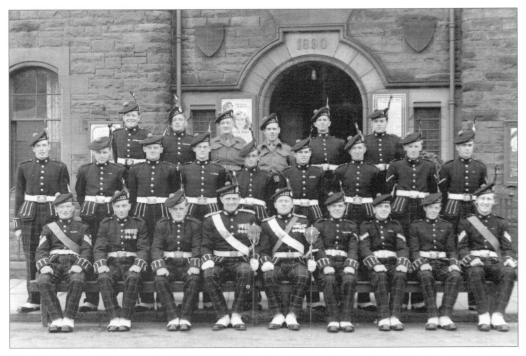

The 'Coronation Contingent' of the King's Own Scottish Borderers pictured in June 1953 outside Loreburn Hall, their drill HQ, on the eve of their departure for London, where they were scheduled to take part in the ceremonies and celebrations surrounding the Coronation of Queen Elizabeth II.

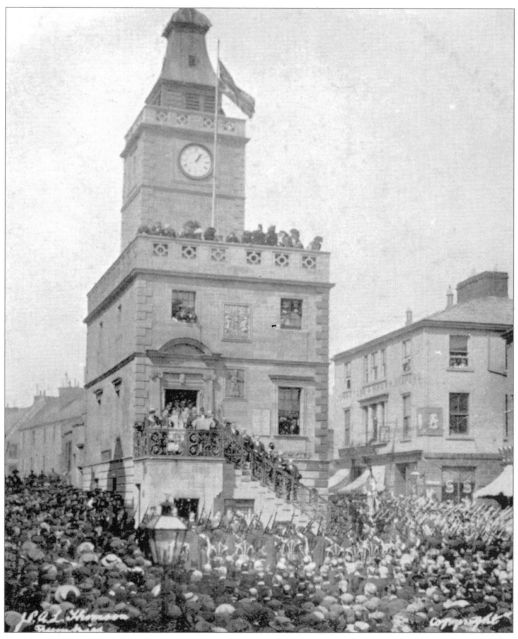

Crowds jam the High Street and besiege the Midsteeple on all sides, in order to hear the official proclamation of King George V on 10 May 1910.

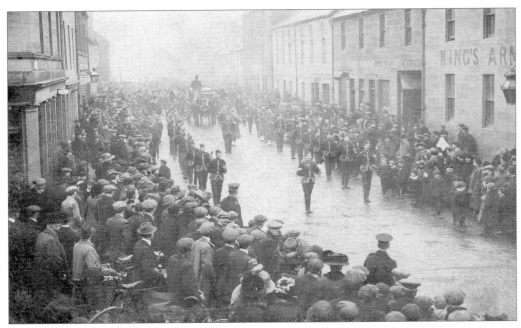

Apart from the date, there is another piece of vital information missing from this photograph of a funeral procession making its way along Glasgow Street: the identity of the deceased. Clearly it was someone of great importance in the town, and possibly with a military connection.

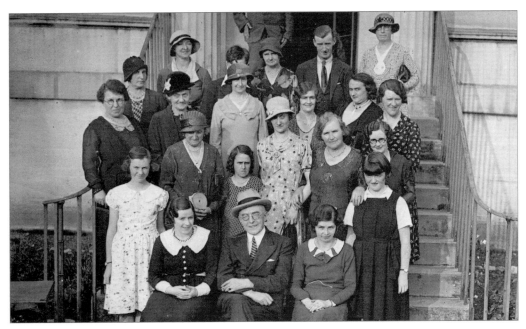

Dr Joseph Hunter (front row, centre), Liberal MP for Dumfriesshire during the 1920s, flanked by party supporters in Castle Street. Local historian Alfred Truckell wrote that 'Joe' Hunter was 'used shamelessly as a political hack' by Lloyd George, and that when he died comparatively young, 'everyone felt that it was of a broken heart'.

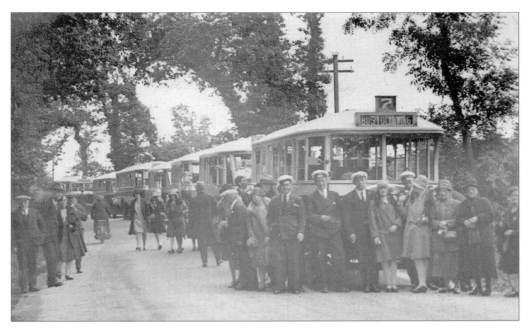

On a summer's day in 1927, an astonishing twenty-three coach-loads of pilgrims drew out of Dumfries in convoy, bound for St Ninian's Cave at Whithorn. Given how little traffic was on the roads then, the coaches' progress must have caused a considerable stirring in the scattered communities along the way.

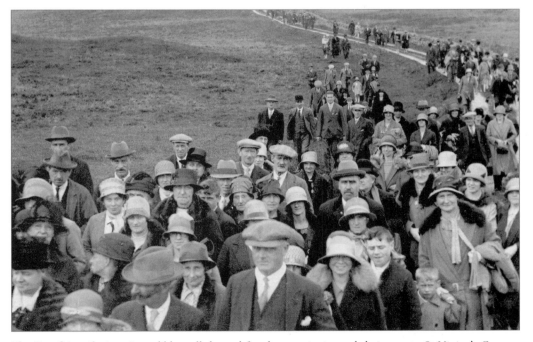

The Dumfries pilgrims (incredibly well dressed for the occasion) wend their way to St Ninian's Cave on the edge of Physgill Bay. Today, scrawled prayers and messages adorn the entrance to the cave, testifying to its enduring significance as a place of pilgrimage.

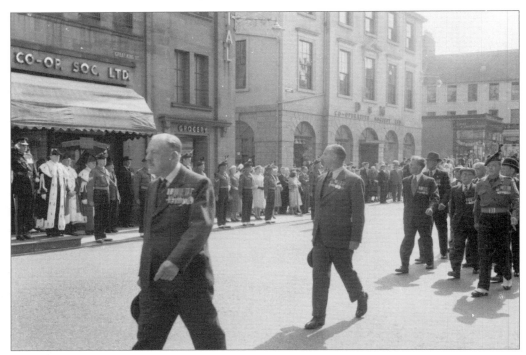

Heads swing to the right during the TA Golden Jubilee Church Parade, on 27 July 1958, as it moves along the High Street past Provost George MacDowall, and an unidentified senior officer taking the salute.

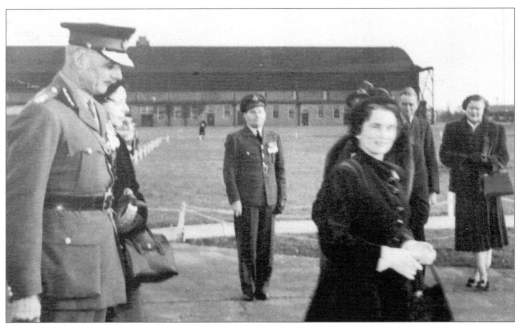

The Duchess of Gloucester, accompanied by Colonel J.G. Crabbe, Lord Lieutenant of Dumfriesshire, arriving at RAF Dumfries on 7 March 1953, in her capacity as Colonel-in-Chief of the King's Own Scottish Borderers. The Freedom of Dumfries was conferred on the regiment later that day.

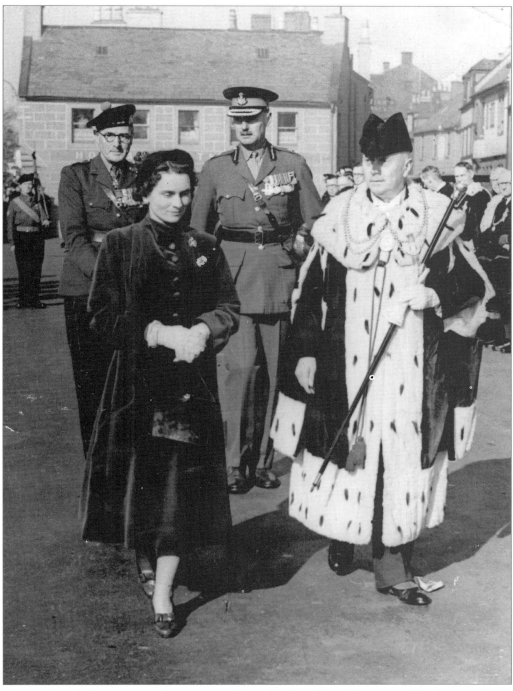

The Duchess of Gloucester – still accompanied by Colonel Crabbe and now joined by Provost Thomas Bell – arrives at Whitesands, where the King's Own Scottish Borderers were about to receive the Freedom of Dumfries.

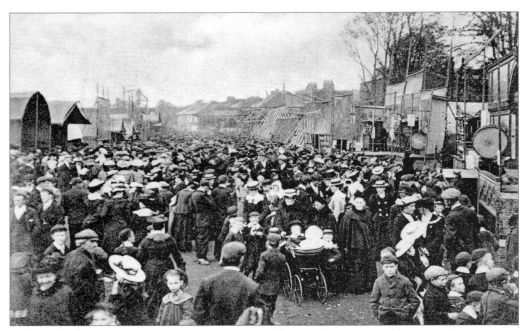

Two views of the Rood Fair from the early 1900s. In addition to being an eagerly anticipated annual event by Dumfries folk, people flocked in from the outlying villages every early autumn to enjoy the fairground atmosphere and entertainments ranged along Whitesands. It was an important holiday occasion and, as these photographs amply demonstrate, people dressed up for it accordingly.

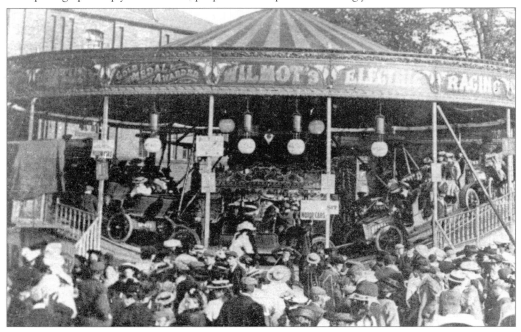

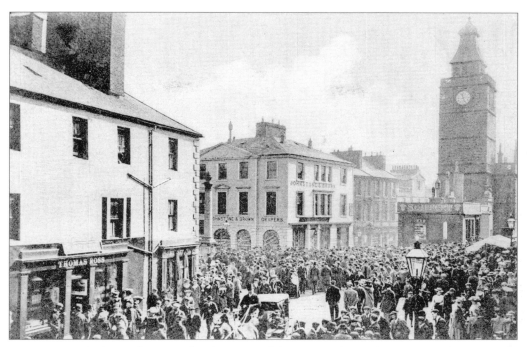

Every town at the heart of an agricultural region will have had its hiring days to recruit labour for the surrounding farms. This photograph, taken at the Midsteeple in 1904, captures the spirit of an occasion that has its origins in the Middle Ages.

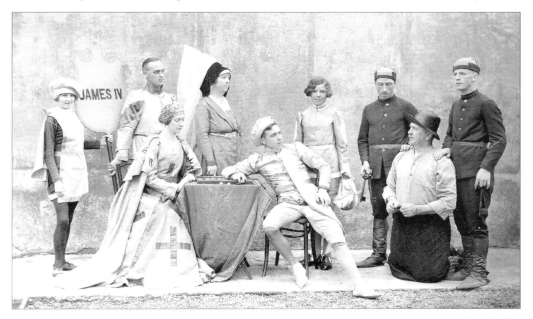

Open-air historical pageants, sometimes on local themes, and performed at Palmerston Park under the direction of John Darlison of the Guild of Players, were a popular feature of the Guid Nychburris festival during the 1930s. Performers seated on either side of the table are Grace McMinn (left) and John Chalmers (right).

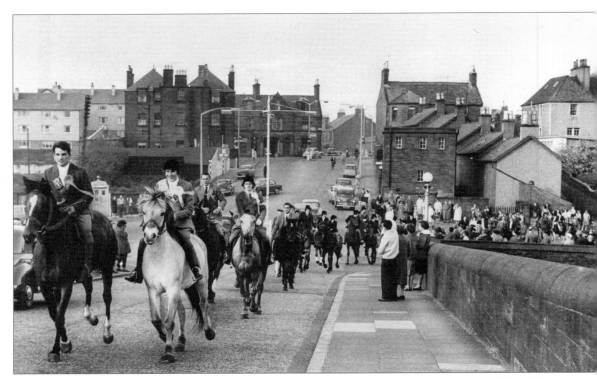

Echoing the town's age-old custom of Riding the Marches, a rideout passes over St Michael's Bridge in 1961, forming an impressive part of the week-long Guid Nychburris festival which is held in Dumfries every summer. The festival, whose title derives from the town's ancient 'curt of guid nychburrhede' (or 'court of good neighbourhood'), which arbitrated disputes between townsfolk, was established in 1932 by local historian and librarian George Shirley and local theatre manager John Darlison. The rideout on this occasion was headed by Cornet Dick Brown.

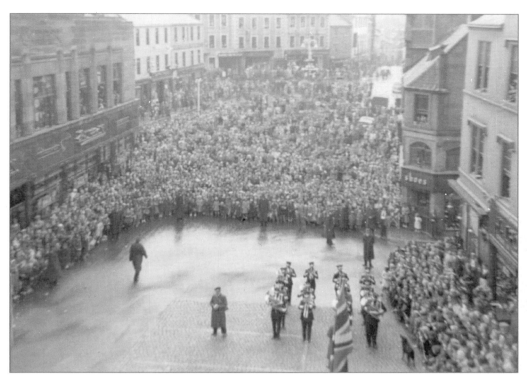

Crowds gather below the Midsteeple during a (rather wet) early 1950s Guid Nychburris festival, to await the crowning of the 'Queen of the South'.

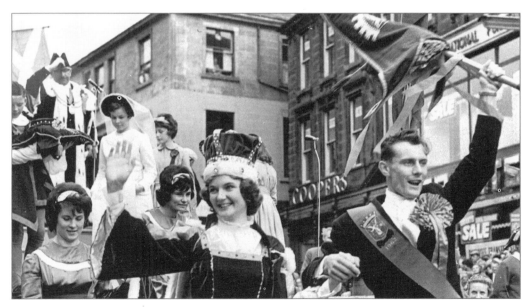

Guid Nychburris 1962, and newly crowned 'Queen of the South', Wilma Gilchrist, together with Cornet Mr F. Solley, acknowledge the cheers of what is always – come rain or shine – a vast crowd around the Midsteeple and High Street, on a day when the whole town is *en fête*.

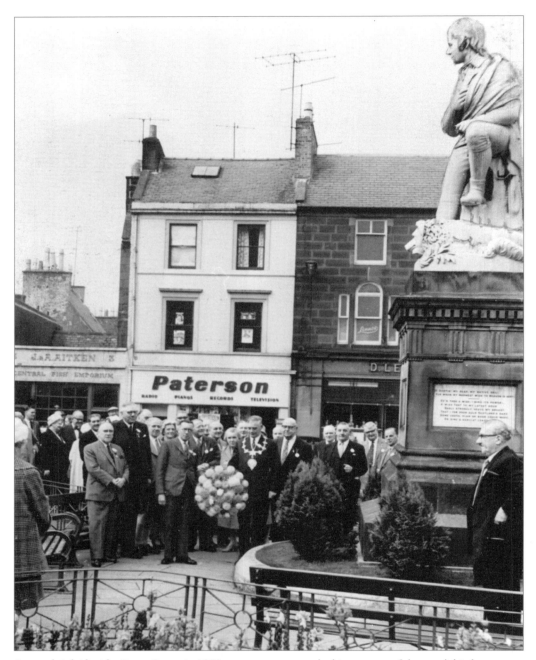

A wreath is laid at the Burns Statue in 1959, to commemorate the bicentenary of the poet's birth.

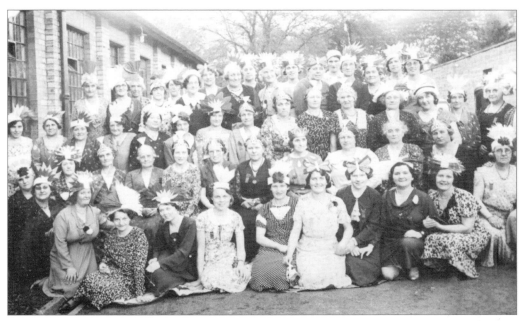

The ladies of Brownhall WRI gather outside their meeting-place, Hannahfield Hall (in the grounds of the Crichton Royal Hospital), in 1935. The unusual headgear was worn to celebrate the Silver Jubilee of King George V and Queen Mary.

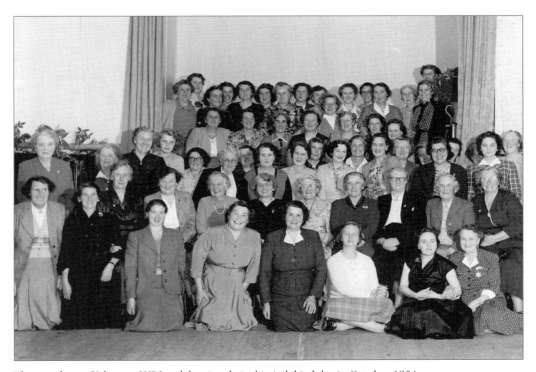

The members of Islesteps WRI, celebrating their thirtieth birthday in October 1954.

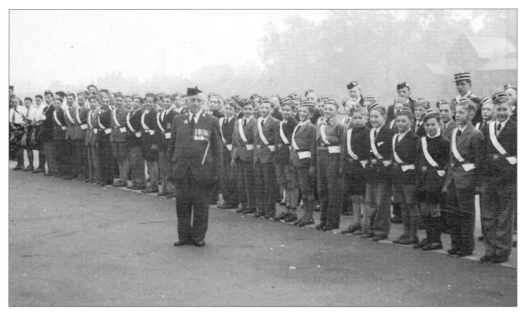

Captain James R. Jardine takes his last parade during the mid-1970s, after serving fifty-four years as Captain of Dumfries 2nd Company of the Boys' Brigade. The BB was established in Dumfries during the early 1920s, with No. 2 Company meeting regularly at South Church Hall in Nith Place.

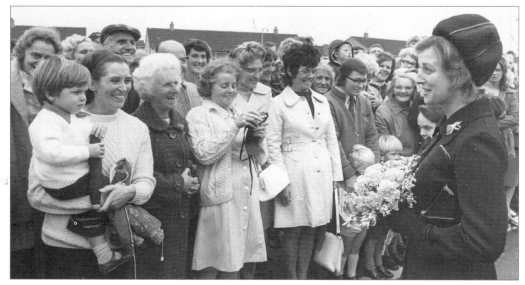

Always a popular member of the Royal Family, Princess Alexandra greets the crowd waiting outside at the official opening of Dumfries Technical College on 24 September 1973. Although currently styled Dumfries and Galloway College, it will long be fondly remembered as 'the Tech' by many local people.

SPORT

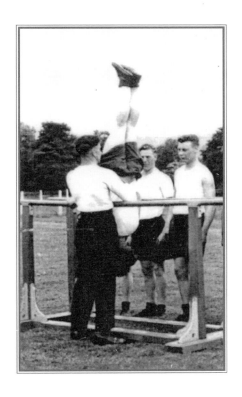

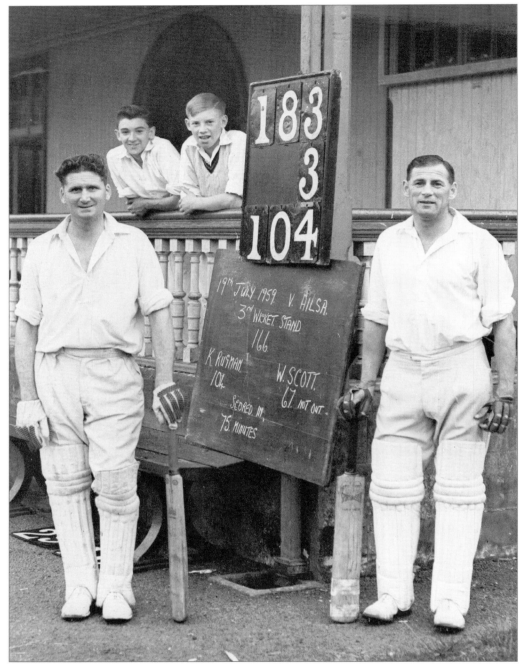

Bill Scott (left) and Ken Rugman (right) pictured during a cricket match at Crichton Royal against Ailsa Hospital of Ayrshire in 1959. The Crichton cricket club is now over a hundred years old, and Rugman's century was the first to be scored at the hospital's ground for thirty-seven years.

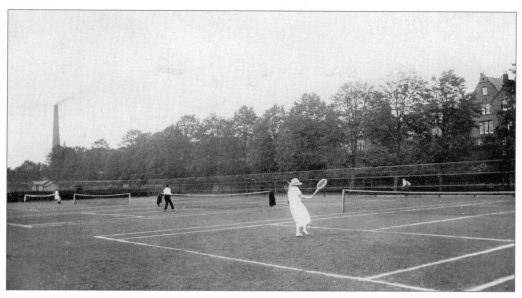

Apart from fickle fashion nothing really changes, as this early 1900s photograph of the public tennis courts in Dock Park shows. They are as popular as ever today, with always that extra surge of interest in the wake of Wimbledon fortnight.

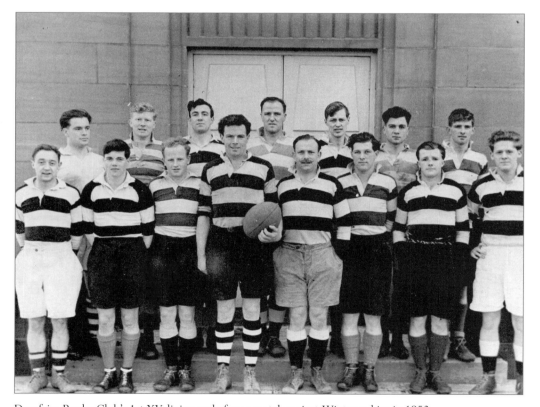

Dumfries Rugby Club's 1st XV, lining up before a match against Wigtownshire in 1952.

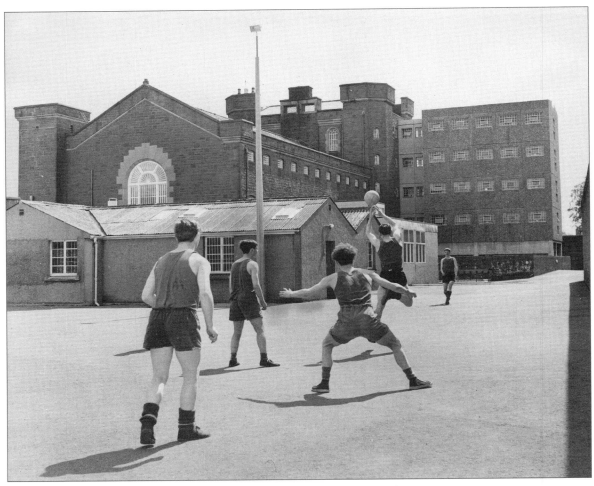

This group of lads at Dumfries Young Offenders' Institution is clearly enjoying a welcome opportunity to work off some excess energy, 1968. The YOI, which forms a part of the Dumfries Prison complex, presently houses about a hundred Young Offenders.

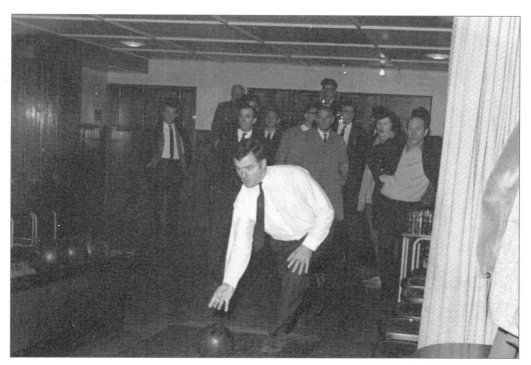

ICI Plastics Division's indoor bowling team's Alex (Sanny) McGregor in action at Needles and Pins (now The Greens) in St Michael Street, 1969.

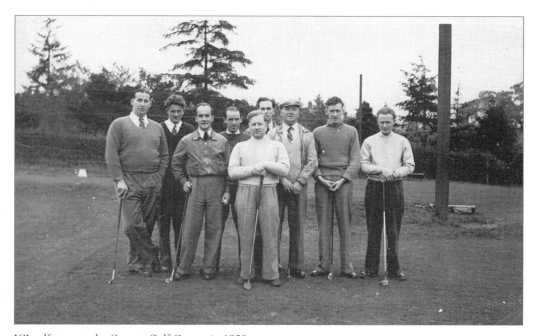

ICI golf team at the County Golf Course in 1950.

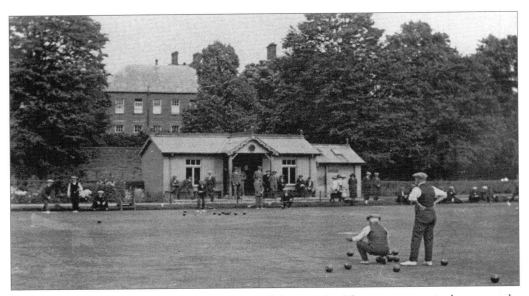

Bowling has long been popular in Dumfries, and it still thrives today. There was a green in the town at the beginning of the eighteenth century, although this photograph of a match in progress at Dock Park is of a more recent vintage: possibly the early 1920s.

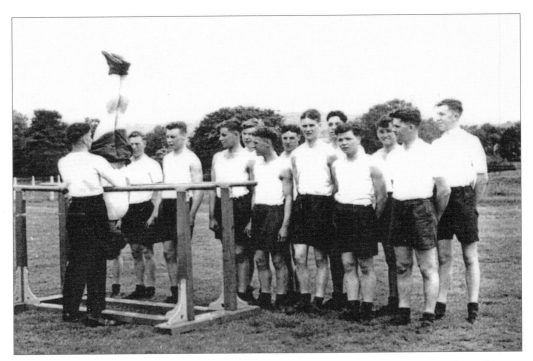

The world has turned upside-down for one of these young 1950s conscripts at RAF Dumfries who, just between themselves, may well feel that this is more like hard work than sport.

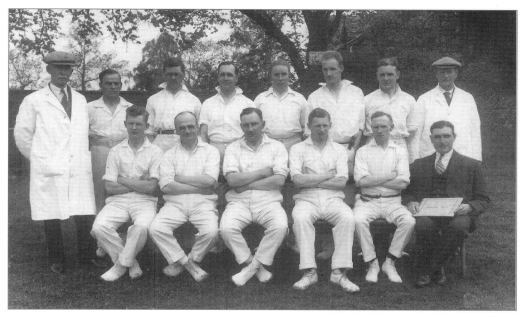

Dumfries Cricket Club was founded in 1853. This team photograph from 1932 includes Sir John Pickles (back row, second right), who lived in Edinburgh Road and was appointed the first Chairman of the South of Scotland Electricity Board.

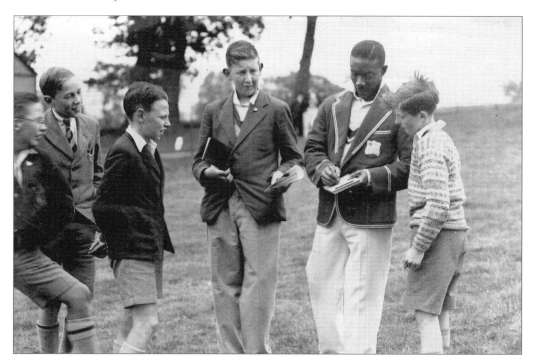

The West Indian Test cricketer, George Headley, signs autographs for local fans, before a home fixture arranged between Mr H.B. Rowan's XI and a selected Dumfriesshire side. Played on 7 June 1934, the match was in aid of the Dumfries Academy Playing Fields Fund.

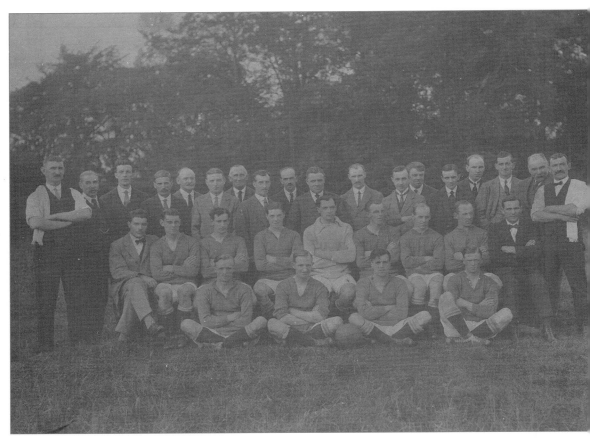

This team photograph of Queen of the South players and officials dates from the club's very earliest days in 1919. Founder-director John Grierson, a local clogmaker, is pictured in the back row, second right.

CHURCH LIFE

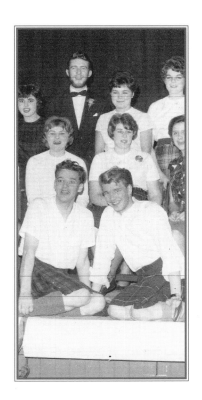

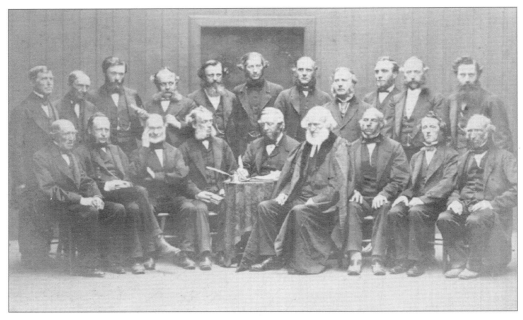

The Rev. Dr James Julius Wood (front row, fourth right) is joined by the Elders and Deacons (and an unseen congregation) of the Free Church of Dumfries, in George Street, during a 'tea and fruit soirée' held on 6 May 1870 in honour of the Minister, who was presented on that occasion with 'a large double-chambered string purse, weighted like a pair of well-filled panniers and containing £315'.

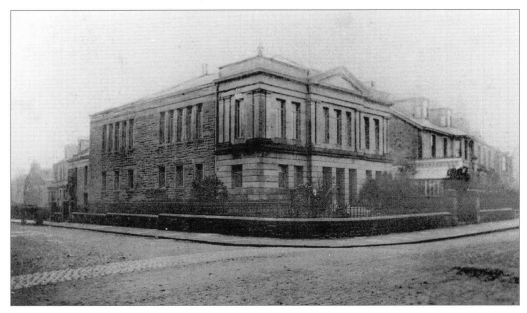

Dumfries Baptist Church, set on the corner of Catherine Street and Newall Terrace. The building, which was opened in 1890, is seen here approximately fifteen years later.

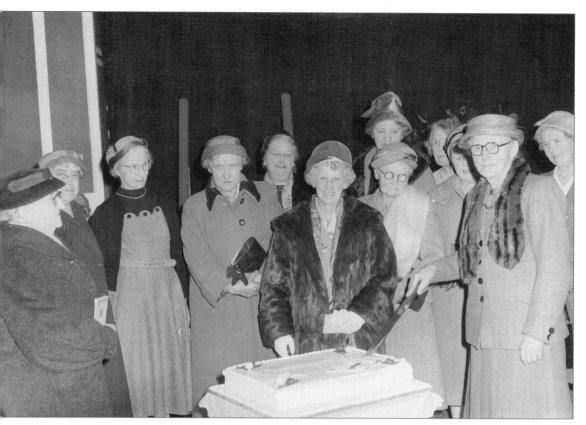

It must have been a chilly evening, judging from the array of hats and long winter coats, when the ladies of St Michael's Church Women's Guild gathered to celebrate their seventieth anniversary on 12 February 1962. The cake is just about to be cut by Miss A.J. Dinwiddie, a former Secretary to the Guild and – at the time of this photograph – its Honorary President. She had been a member for over sixty years.

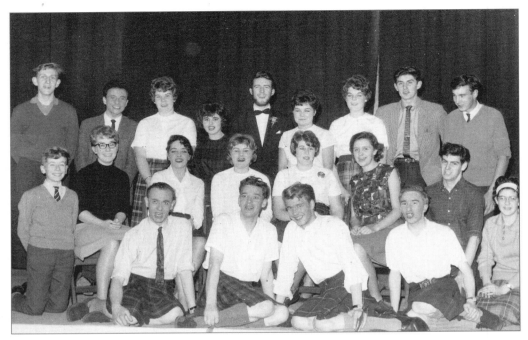

St Michael's Youth Club concert party, 1969.

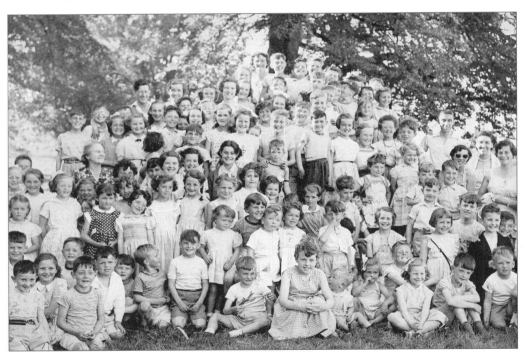

The endless delights of a summer's day beckon for these children from St Michael's Sunday School, enjoying an outing in the grounds of Drumlanrig Castle, June 1957. Doubtless much persuasion was needed to keep them assembled long enough for this group photo.

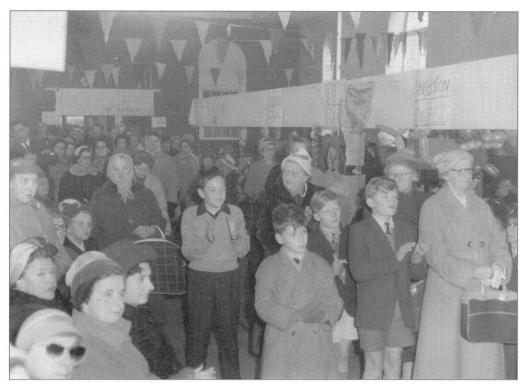

Jumble sales change very little over the years, except for the amounts raised. On this occasion at St Michael's in November 1961, the £125 gathered in aid of church funds was considered a truly handsome sum.

The actor, John Laurie, opens the St Michael's Women's Guild sale of work in 1965. Laurie, a local man educated at Dumfries Academy, is universally and fondly remembered as Private Frazer in BBC TV's long-running and oft-repeated comedy series, *Dad's Army*.

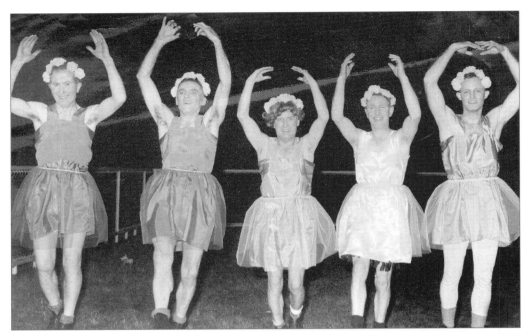

This could be a species of Highland Fling but, in fact, these doughty members of St Michael's Men's Club (including the Rev. Oliver Clark, far right) were impersonating a group of dainty ballerinas, at a church concert given in 1962. They were watched by an audience of over four hundred.

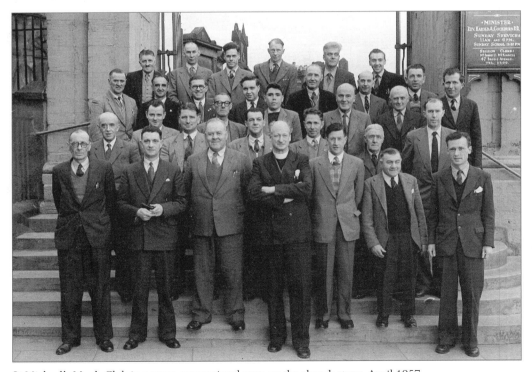

St Michael's Men's Club in a more conventional pose on the church steps, April 1957.

'YOUTH'S THE SEASON MADE FOR JOYS . . .'

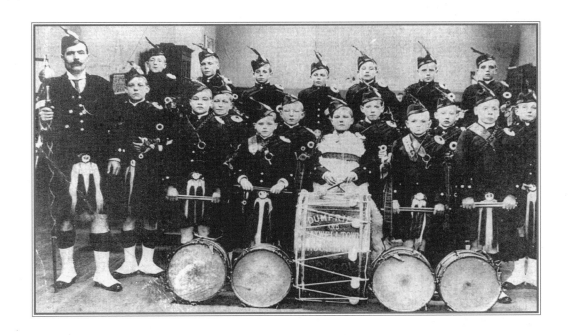

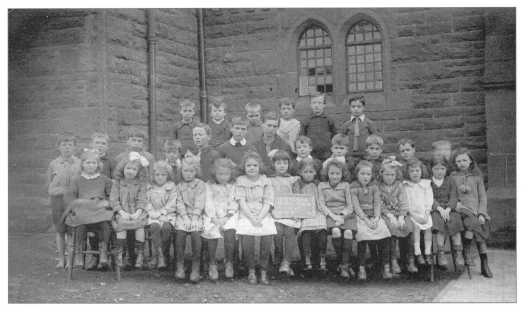

Brownhall School, class of 1921.

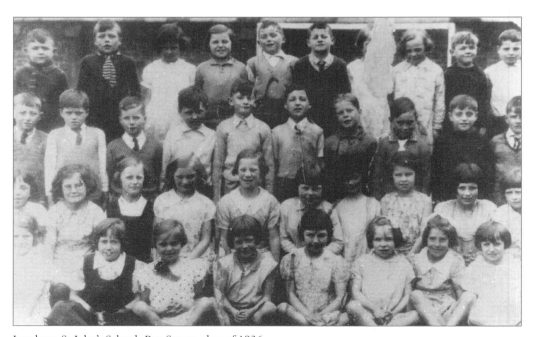

Loreburn St John's School, Rae Street, class of 1936.

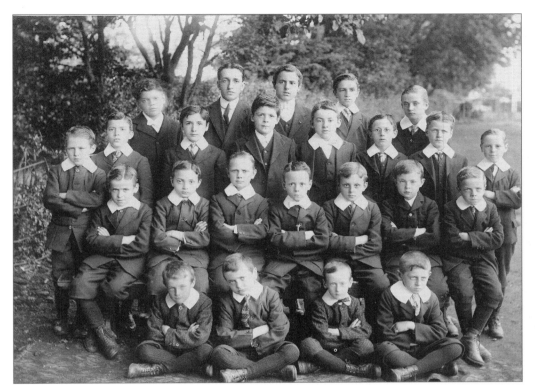

Pupils at St Joseph's College, *c.* 1903.

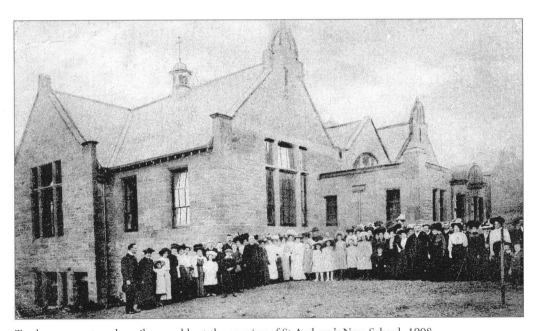

Teachers, parents and pupils assemble at the opening of St Andrew's New School, 1908.

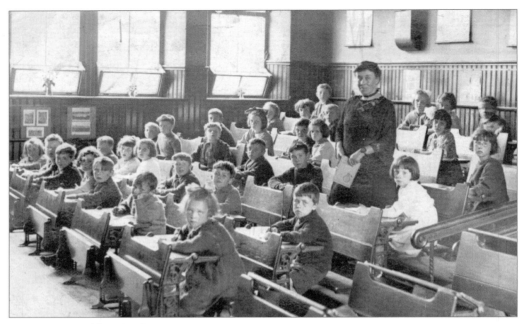

George Street Public School, 1924.

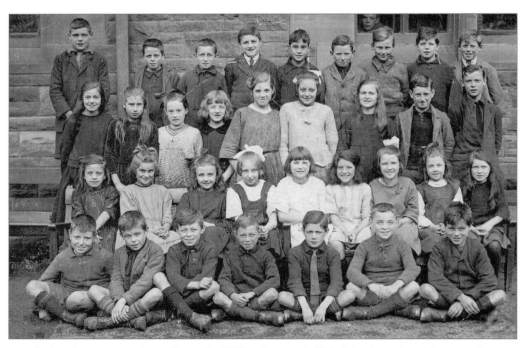

. . . And again, two years later. From the 1930s, the town's High School was based here, until a new complex was built and opened at Marchmount in 1961. This is now Loreburn Primary School.

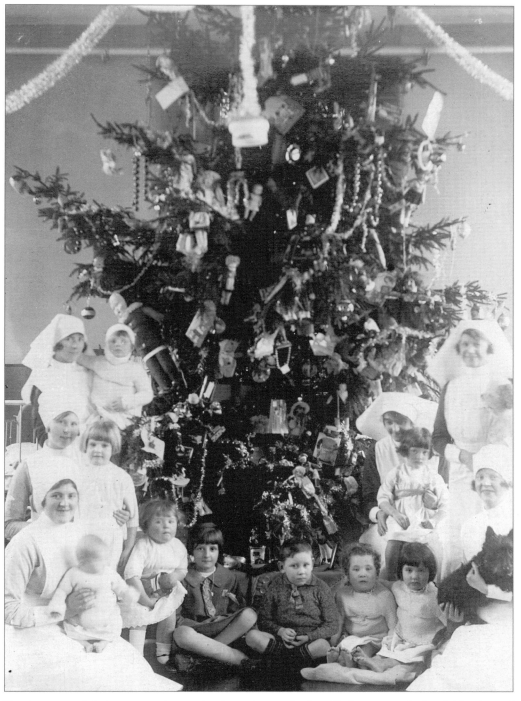

Nursing staff and their young patients gather beneath a resplendent Christmas tree, in the children's ward at Dumfries and Galloway Royal Infirmary during the early 1930s.

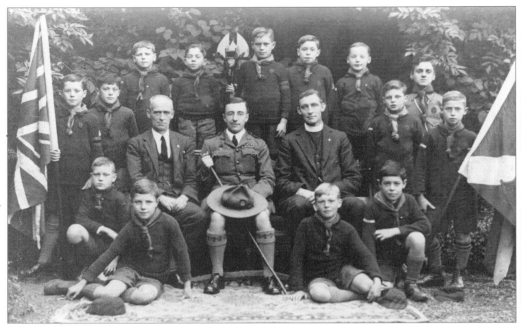

YMCA Wolf Cubs, *c.* 1921.

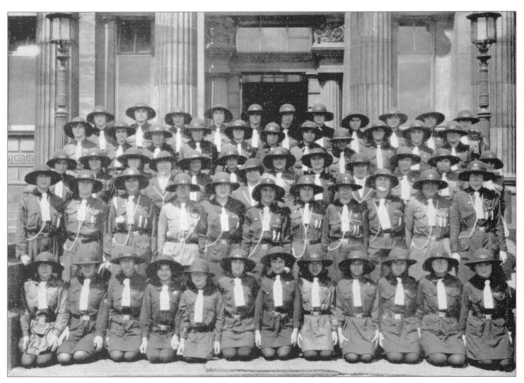

1st Dumfriesshire Girl Guide Company (Dumfries Academy) 1929. Formed in 1912, with membership confined to Academy pupils, the troop comprised three patrols: the Fuchsia, the White Rose and the Thistle.

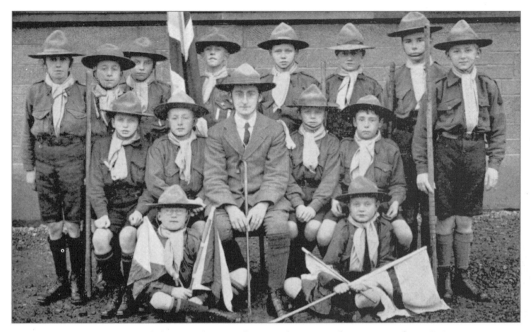

Scoutmaster Mr Gregory, and the Dumfries Academy Cadet troop of Boy Scouts, late 1913.

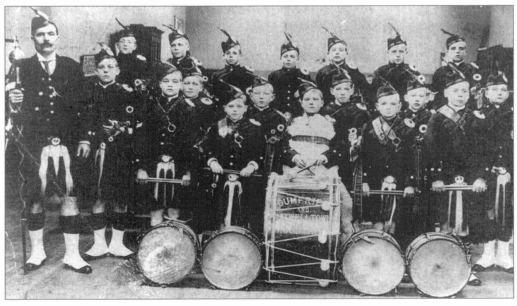

Dumfries and Maxwelltown Industrial School Pipe Band, *c.* 1919. Juveniles convicted of minor offences were sent here, so the angelic faces could be deceptive.

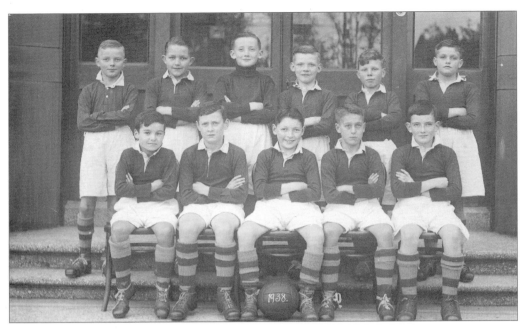

St Joseph's College 1st Junior Football XI, 1938.

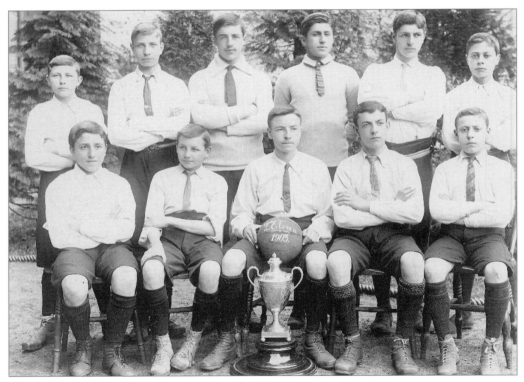

A collar and tie with football boots would be decidedly out of place in the 1990s, but it was clearly the height of fashion for St Joseph's College Senior 2nd Football XI in 1903.

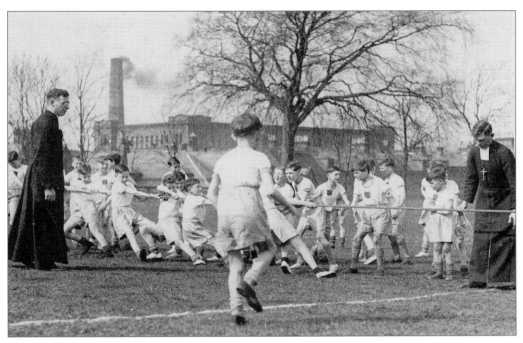

Two of St Joseph's Marist Brothers supervise an energetic tug-o'-war at a College Sports Day in the 1950s.

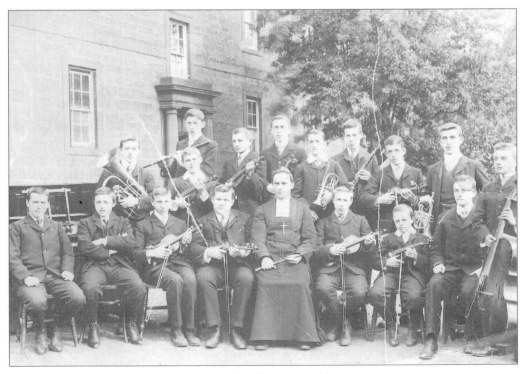

St Joseph's College Band, pictured here just before the First World War.

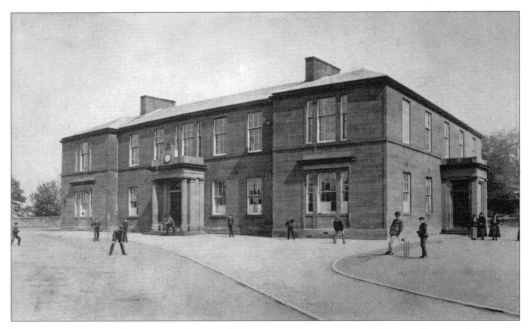

Dumfries Academy before 1897, when the building seen here was demolished and replaced by a new structure. It is said that the playwright J.M. Barrie, who was one of the Academy's pupils during the 1870s, can be seen playing in this photograph – but you would be hard pressed to identify him!

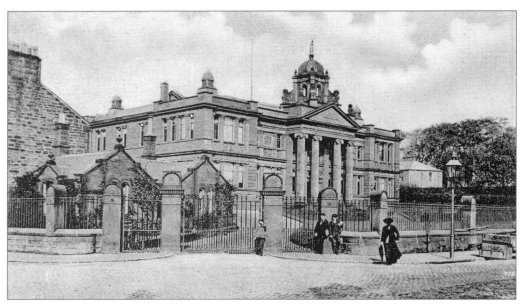

Dumfries Academy, c. 1907. 'A handsome building of classical design', boasted one old guide to the town, '. . . with a dome 62 feet high, surrounded by a figure of learning'.

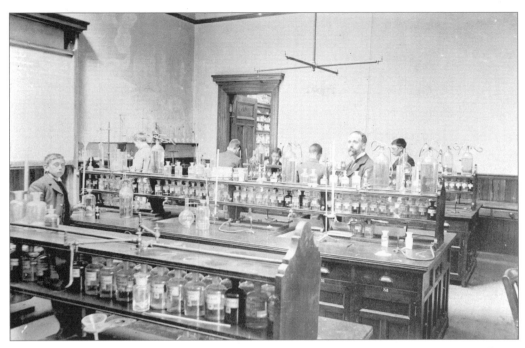

A state-of-the-art school science laboratory, 1897-style. This photograph by John Rutherford was taken in the new Dumfries Academy building.

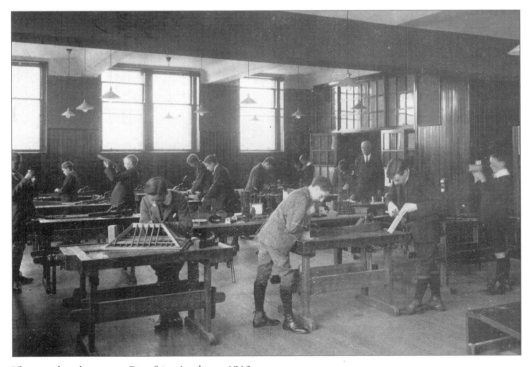

The woodwork room at Dumfries Academy, 1913.

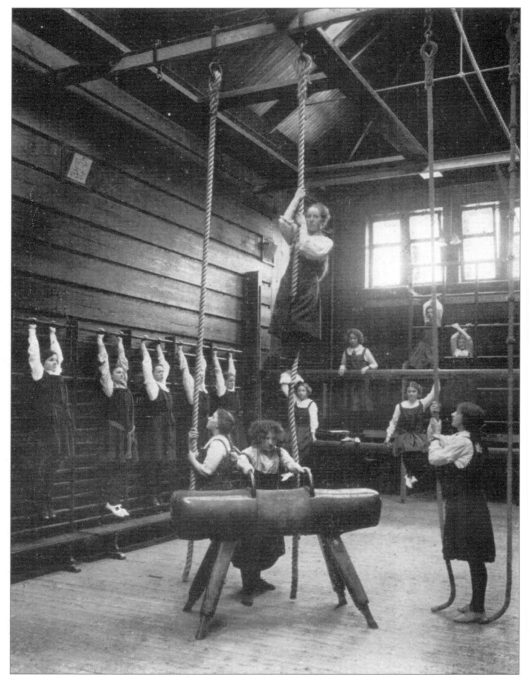

There is a distinct air of the torture-chamber in this photograph of Dumfries Academy's gymnasium, *c*. 1913.

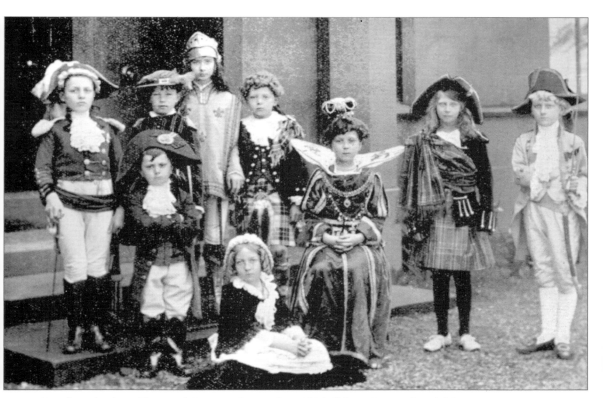

Dumfries Academy Historical Pageant, Empire Day 1916. 'These Empire Day celebrations were more elaborate and more successful than ever', the Academy's magazine recorded later that year. 'It was a glorious day – a day of sunshine and warmth, well suited for the occasion; a day that made everyone think of summer fields and maypoles. . . . Perhaps the most interesting item', it continued, 'was the Historical Pageant by the pupils of the Junior School. These youthful members did their best to refresh our memories of the history of our land, and to convey us back to the days of 'good Queen Bess', and Ralegh, of Nelson, Wellington and Napoleon, of Prince Charlie and Flora MacDonald, and to the distressing time in which Florence Nightingale lived and worked so faithfully to relieve the suffering in the Crimea'.

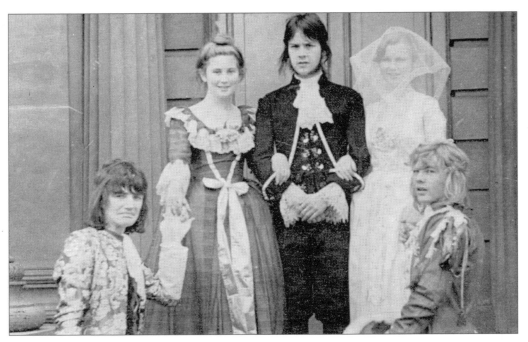

Dumfries Academy senior pupils prepare for their 1974 production of Shakespeare's *The Taming of the Shrew*. In keeping with the spirit of the age, perhaps, the boys' costumes have a slightly 'glam-rock' appearance.

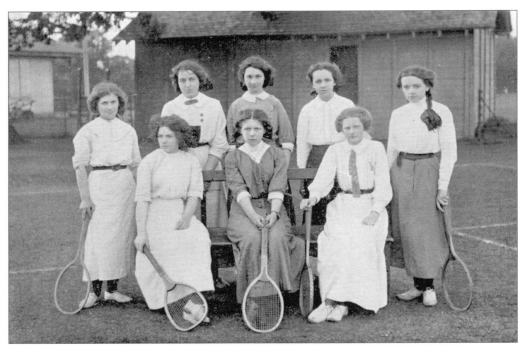

Dumfries Academy Tennis Team, 1912. Kate Swan (front row, middle) was the Academy's reigning tennis singles' champion at the time this photograph was taken.

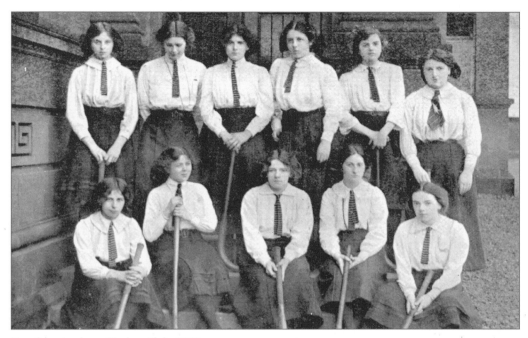

Dumfries Academy Hockey Club, 1913.

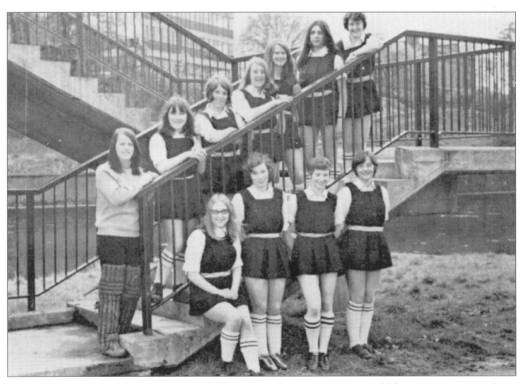

Dumfries Academy Hockey XI just over half a century later, in 1968. It could be my imagination, but I wonder if just a hint of the St Trinian's influence has crept in over the intervening years.

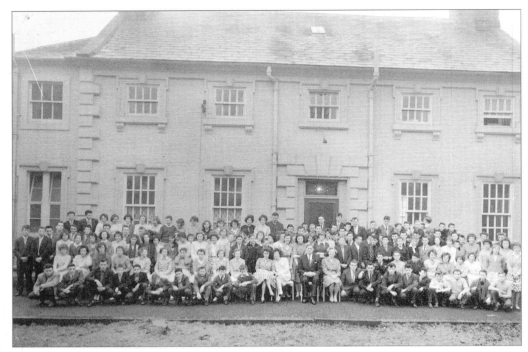

In its heyday, Dumfries Youth Centre enjoyed a large and enthusiastic following, as can be seen in this photograph of the members gathered – with Youth Leaders Mr and Mrs Ken Rugman (front row, centre) – outside their Irish Street premises (an impressive building designed by Robert Adam) in February 1963.

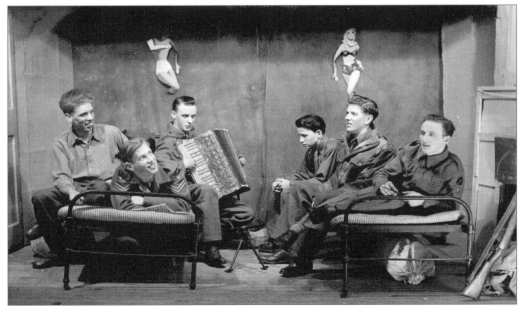

Members of Dumfries Youth Centre perform Ken Rugman's play, *They Came By Night*, based on his D-Day experiences. Mounted in 1954, the production played for a week in the Youth Centre's cellars, to a nightly audience of two hundred people.

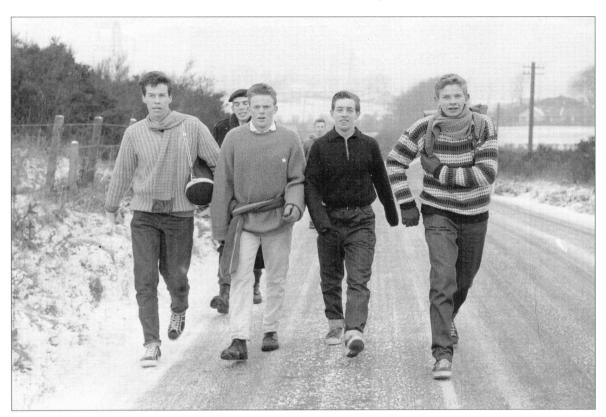

At the beginning of January, every year from about 1957 to 1964, Ken Rugman organized a marathon walk for Youth Centre members beginning in Irish Street. The purpose of the event was to take the Scots flag into England, the winner being the person who could carry the flag for the furthest distance. This photograph, taken between Dumfries and Collin on 2 January 1962, shows that year's eventual winner, Tony Irvine (front, second left) who, according to a contemporary local newspaper report, completed the formidable distance of 51½ miles.

ACKNOWLEDGEMENTS

I am grateful to the following for the loan of photographs and for background information:

Mrs Rene Anderson, Ian Ball, David Beeton, Norman Blount, Chris Boston, British Red Cross, Mr Connolly, Brian Coupland, Bob Cowan, Mrs Nancy Dalgleish, Dumfries Academy, Dumfries Aviation Museum, Dumfries Cricket Club, Dumfries Prison, Dumfries Rugby Club, Dumfries and Galloway College, Dumfries and Galloway Health Board, *Dumfries and Galloway Standard*, Mike Gault, Mrs Audrey Girling, Robert Grierson, Mrs A. Haining, ICI, Arthur Jardine, Jimmy Kirk, Peter Kormylo, Mrs Audrey Millar, Robin Miller, Mrs Mary Parker, Penman Engineering, David Reid, Livie Reid, Ken Rugman, St Joseph's College, Shortridge, Ernie Smith, George Stobbs, Transport and General Workers' Union, Captain Turnbull, Peter Walker, the Garry Ward Collection, Mrs Morag Williams, Mr and Mrs Cyril Wise, Women's Royal Voluntary Service, Duncan Wyllie.

BRITAIN IN OLD PHOTOGRAPHS

LONDON

Acton *T & A Harper-Smith*
Around Whetstone *J Heathfield*
Barnes, Mortlake and Sheen *P Loobey*
Balham and Tooting *P Loobey*
Brixton and Norwood *J Dudman*
Crystal Palace, Penge and Anerley
 M Scott
Ealing and Northfield *R Essen*
Greenwich and Woolwich *K D Clark*
Hackney: A Second Selection *D Mander*
Hammersmith and Shepherds Bush
 J Farrell & C Bayliss
Hampstead to Primrose Hill *M Holmes*
Fairey Aircraft *R Sturdivant*
Islington *D Withet & V Hart*
Kensington and Chelsea *B Denny &*
 C Starren
Lewisham and Deptford: A Second
 Selection *J Coulter*
Marylebone and Paddington *R Bowden*
Royal Arsenal, The, Woolwich
 R Masters
Southwark *S Humphrey*
Stepney *R Taylor & C Lloyd*
Stoke Newington *M Manley*
Streatham *P Loobey*
Theatrical London *P Berry*
Uxbridge, Hillingdon and Cowley
 K Pearce
Wimbledon *P Loobey*
Woolwich *B Evans*

MONMOUTHSHIRE

Chepstow and the River Wye *A*
 Rainsbury
Monmouth and the River Wye
 Ed. Monmouth Musuem

NORFOLK

Cromer & District *M Warren*
Great Yarmouth *M Teun*
Norfolk at War *N Storey*
North Walsham & District *N Storey*
Wymondham and Attleborough *P Yaxley*

NORTHAMPTONSHIRE

Around Stony Stratford *A Lambert*

NOTTINGHAMSHIRE

Arnold and Bestwood *M Spick*
Arnold and Bestwood II *M Spick*
Around Newark *T Warner*
Changing Face of Nottingham, The
 G Oldfield
Kirkby and District *F Ashley et al*
Mansfield *Old Mansfield Society*
Newark *T Warner*
Nottingham Yesterday and Today
 G Oldfield
Sherwood Forest *D Ottewell*
Vale of Belvoir *T Hickman*
Victorian Nottingham *M Payne*

OXFORDSHIRE

Around Abingdon *P Horn*
Around Didcot and the Hagbournes
 B Lingham

Around Henley-on-Thames *S Ellis*
Around Highworth & Faringdon
 G Tanner
Around Wallingford *D Beasley*
Around Wheatley *M Gunther*
Around Witney *C Mitchell*
Around Woodstock *J Bond*
Banburyshire *S Gray*
Burford *A Jewell*
Garsington *M Guntner*
Oxford: The University *J Rhodes*
Oxfordshire Railways: A Second
 Selection *L Waters*
Thame To Watlington *N Hood*
Wantage, Faringdon and the Vale
 Villages *N Hood*
Witney *T Worley*
Witney District *T Worley*

POWYS

Brecon *Brecknock Museum*
Welshpool *E Bredsdorff*

SHROPSHIRE

RAF Cosford *A Brew*
Shrewsbury *D Trumper*
Shrewsbury: A Second Selection
 D Trumper
Whitchurch to Market Drayton
 M Morris

SOMERSET / AVON

Around Keynsham and Saltford *B Lowe*
Around Taunton *N Chipchase*
Around Weston-Super-Mare *S Poole*
Bath *J Hudson*
Bridgwater and the River Parrett
 R Fitzhugh
Bristol *D Moorcroft*
The Changing Face of Keynsham *B Lowe*
 & M Whitehead
Chard and Ilminster *G Gosling*
Crewkerne and the Ham Stone Villages
 G Gosling
Frome *D Gill*
Mendips, The *C Howell*
Midsomer Norton and Radstock
 C Howell
Minehead *J Astell*
Somerton and Langport *G Gosling*
Taunton *N Chipchase*
Wells *C Howell*
Weston-Super-Mare *S Poole*

STAFFORDSHIRE

Around Leek *R Poole*
Around Rugeley *T Randall*
Around Stafford *J Anslow*
Around Tamworth *R Sulima*
Around Tettenhall and Codsall *M Mills*
Black Country Railways *N Williams*
Black Country Road Transport *J Boulton*
Black Country Transport: Aviation
 A Brew
Brierley Hill *S Hill*
Bushbury *A Chatwin*
Heywood *J Hudson*
Lichfield *H Clayton*

Pattingham and Wombourne *M Mills*
Sedgley and District *T Genge*
Smethwick *J Maddison*
Stafford *J Anslow & T Randall*
Staffordshire Railways *M Hitches*
Stoke-on-Trent *I Lawley*
Tipton *J Brimble & K Hodgkins*
Walsall *D Gilbert*
Wednesbury *I Bott*
West Bromwich *R Pearson*

SUFFOLK

Around Mildenhall *C Dring*
Around Woodbridge *H Phelps*
Ipswich: A Second Selection *D Kindred*
Lowestoft *I Robb*
Southwold to Aldeburgh *H Phelps*
Stowmarket *B Malster*
Suffolk at Work: Farming and Fishing
 B Malster

SURREY

Around Epsom *P Berry*
Cheam And Belmont *P Berry*
Croydon *S Bligh*
Farnham: A Second Selection *J Parratt*
Kingston *T Everson*
Richmond *Ed. Richmond Local*
 History Society
Sutton *P Berry*

SUSSEX

Around Crawley *M Goldsmith*
Around Haywards Heath *J Middleton*
Around Heathfield *A Gillet*
Around Heathfield: A Second Selection
 A Gillet
Around Worthing *S White*
Arundel and the Arun Valley *J D Godfrey*
Bishopstone and Seaford *P Pople*
Bishopstone and Seaford: A Second
 Selection *P Pople & P Berry*
Brighton and Hove *J Middleton*
Brighton and Hove: A Second Selection
 J Middleton
Crawley New Town *P Allen & J Green*
East Grinstead *N Dunnachie*
Hastings *P Haines*
Hastings: A Second Selection *P Haines*
High Weald, The *B Harwood*
High Weald: A Second Selection
 B Harwood
Horsham and District *T Wales*
Lancing and Sompting *P Fry*
Lewes *J Middleton*
RAF Tangmere *A Saunders*

TAYSIDE

Dundee at Work *J Murray*

WARWICKSHIRE

Along the Avon from Stratford to
 Tewkesbury *J Jeremiah*
Around Coventry *D McGrory*
Around Leamington Spa *J Cameron*
Around Leamington Spa II *J Cameron*
Around Warwick *R Booth*
Bedworth *J Burton*

Birmingham Railways *M Hitches*
Coventry: A Second Selection *D McGrory*
Nuneaton *S Clews*
Rugby *Rugby Local History*
 Research Group
Stourbridge *R Clarke*

WESTMORLAND

Kendal *M Duff*

WILTSHIRE

Around Amesbury *P Daniels*
Around Devizes *D Buxton*
Around Highworth *G Tanner*
Around Highworth & Faringdon
 G Tanner
Around Melksham *Ed. Melksham and*
 District Historical Association
Around Salisbury *P Daniels*
Around Wilton *P Daniels*
Around Wootton Bassett, Cricklade and
 Purton *T Sharp*
Castle Combe to Malmesbury *A Wilson*
Chippenham and Lacock *A Wilson*
Corsham & Box *A Wilson*
Marlborough: A Second Selection
 P Colman
Nadder Valley *R Sawyer*
Salisbury *P Saunders*
Salisbury: A Second Selection *P Daniels*
Salisbury: A Third Selection *P Daniels*
Swindon: A Third Selection *Ed. The*
 Swindon Society
Swindon: A Fifth Selection *B Bridgeman*
Trowbridge *M Marshman*

WORCESTERSHIRE

Around Malvern *K Smith*
Around Pershore *M Dowty*
Around Worcester *R Jones*
Evesham to Bredon *F Archer*
Redditch and the Needle District
 R Saunders
Redditch: A Second Selection
 R Saunders
Tenbury Wells *D Green*
Worcester *M Dowty*
Worcester in a Day *M Dowty*
Worcestershire at Work *R Jones*

YORKSHIRE

Around Rotherham *A Munford*
Around Thirsk *J Harding & P Wyon*
Beverley *P Deans & J Markham*
Bridlington *I & M Sumner*
Holderness *I & M Sumner*
Huddersfield: A Second Selection
 H Wheeler
Huddersfield: A Third Selection
 H Wheeler
Leeds Road and Rail *R Vickers*
Otley & District *P Wood*
Pudsey *Pudsey Civic Society*
Scarborough *D Coggins*
Skipton and the Dales *Ed. Friends of*
 Craven Museum
Wakefield *C Johnstone*
Yorkshire Wolds, The *I & M Sumner*